W9-BMX-708

Shoes

Shoes

WHAT EVERY WOMAN
SHOULD KNOW

STEPHANIE PEDERSEN

D&C

David and Charles

A DAVID & CHARLES BOOK

David & Charles is a subsidiary of F+W (UK) Ltd.,
and F+W Publications Inc. company

First published in the UK in 2005
Copyright © Studio Cactus 2005

Distributed in North America
by F+W Publications, Inc.
4700 East Galbraith Road
Cincinnati, OH 45236
1-800-289-0963

A catalogue record for this book is available
from the British Library.

ISBN 0 7153 2234 6

Printed in Singapore by Star Standard
for David & Charles
Brunel House Newton Abbot Devon

Visit our website at
www.davidandcharles.co.uk

David & Charles books are available from all
good bookshops; alternatively you can contact our
Orderline on (0)1626 334555 or write to us at
FREEPOST EX2110, David & Charles Direct, Newton
Abbot, TQ12 4ZZ (no stamp required UK mainland).

Contents

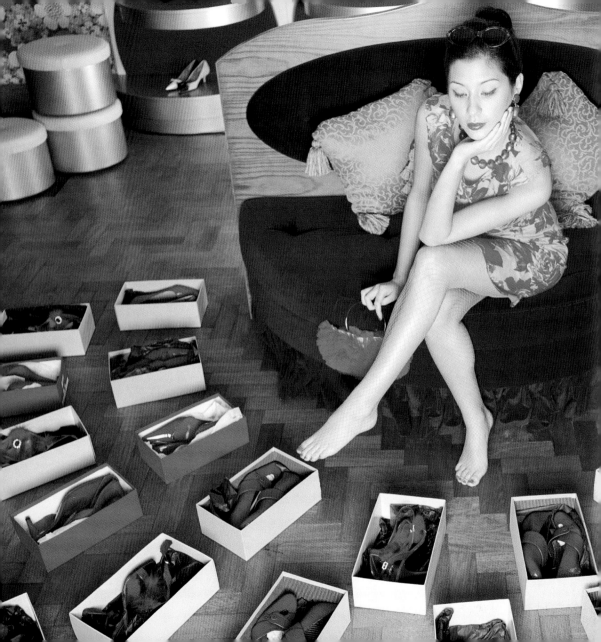

The World at Your Feet

The shoe – practical necessity or object of desire? Never has an accessory been so revered and lusted after! From footwear's first steps to the phenomenon of today's mass market appeal, the shoe's history has been shaped by various cultural attitudes towards gender, sexuality, wealth and social status. As instruments of repression and pain, beauty and creativity, shoes have taken many guises, fulfilled many roles and presented us with some of the most weird and wonderful fashion trends ever seen.

Introduction

The shoe: a brief history

From Egyptian sandals to Jimmy Choos, footwear fashion has come on in leaps and bounds. Prehistoric feet were fur-clad to keep them warm, dry and splinter-free but these days sexy slingbacks and towering stilettos rule the roost – whatever the cost. Leaving practicality aside, shoes are now about style and status, meaning more than our ancestors could have ever imagined.

We have so many choices today that it's easy to forget that 3,000 years ago shoes were merely simple creations fashioned out of tree bark, plant fibres and scraps of animal skin – in other words, the early sandal. Make no mistake, though, these were not sexy shoes. They were purely utilitarian, do-it-yourself creations, designed solely to protect the feet. There were no graceful heels, no toe cleavage and no exciting

ROMAN OMEN
An early forerunner to the shoe we know today, this caliga sandal was a military shoe but wasn't great in wet weather.

flourishes to draw a man's gaze to your flirty pedicure. Early shoes were unisex affairs that made no attempt to flatter the feet.

The shoe takes off

As man and shoe evolved, so fashion began to rear its head. It was a case of the haves and have-nots. On the one foot you had peasants, slaves, workers and other non-aristocrats wearing

SHOES OF THE 20TH CENTURY

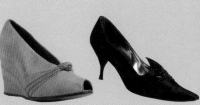

1900s
The century kicks off with the Edwardian elegance of these kid leather Balmoral boots.

1910s
Judging by these stunning court shoes, this was the decade of the truly divine.

1920s
Roaring onto the fashion scene was this gold brocade bar shoe with elasticated strap.

1930s
Harrods leads the way with this brown leather and beige openwork fabric court shoe.

1940s
Life during wartime: pretty in pink are these canvas, peep-toe, wedge court shoes.

1950s
Oh l'amour, c'est Christian Dior! Black satin stilettos with glass bead trim.

whatever shoes they could make or buy (or wearing none at all), while on the other foot royalty and other well-heeled folk designed completely impractical shoes and competed with each other to see who could wear the most extreme styles – think crackows of the Middle Ages and 15th-century chopines, for example (pages 18 and 20 respectively).

Common sense prevails

For centuries, shoes remained either boringly sensible or fancifully impractical, depending on your status. This division began to blur only after the Industrial Revolution, when a prominent middle class emerged. Suddenly, what had always been the special preserve of the privileged few – desirable footwear – had become the happy hunting ground of all. This isn't to say that every shoe was now necessarily comfortable – which woman doesn't own a toe-pinching, favourite pair of heels? It just meant that, more than ever, we had greater freedom of choice of shoes.

> *"I don't want to feel a shoe; I want the shoe to become part of me."*
>
> LESLIE BROWNE, AMERICAN BALLERINA

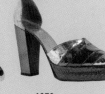

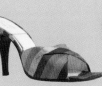

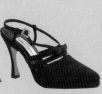

1960s
French fancy: were these Gallic black and white plastic boots cousins of our wellies?

1970s
Mock crocodile: these metallic-coloured, faux reptile-skin platform sandals had real bite.

1980s
These multicoloured silk mules added a spectrum of glamour to the yuppie culture.

1990s
Choo too? The decade when every woman aspired to own a pair of Jimmy's creations.

2000s
More than 100 years later, and the heel's still here. But what next in shoe innovation?

Cultural attitudes towards feet

Anatomically, feet are what we use for standing and walking. But they *can* mean so much more. In the West they are the perfect vehicle for cute shoes, pleasing women (and often men!), and we pamper them with pedicures and paint our nails. But is that just us? How do other societies regard their feet?

In other cultures – some modern, some ancient – feet take on a much weightier role, influencing one's marriagability and position in society, as well as luck, health and death. For instance, having a wardrobe of different sandals was important to the wealthy Egyptians of 3000 BC. Shoes were so revered in this culture that shoes and shoemakers were routinely pictured on temple walls.

Outdoors only
In ancient and modern Japan, shoes are for wearing out of the house and thus are removed immediately before entering a person's home. For indoor wear, many Japanese still wear the traditional Tabi sock, which separates the big toe from the other four digits. Displaying the soles of your feet in Japan is also considered insulting – it is showing another person the 'lowest' part of you. In other words, how can you respect someone if you're revealing the soles of your feet to them?

Small is beautiful
Chinese foot-binding began in the 10th century in the royal court and spread to all but peasant women, who needed to be able to work in the fields. A child's mother bound her young daughter's feet so that the toes bent

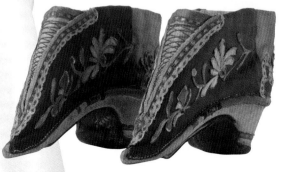

PAINTING YOUR NAILS
For many of us gals, feet are a wonderful opportunity to accessorize and feminize, with nail varnish as well as great shoes.

under and the bones in the foot broke, forcing the front and back of the foot together. The ideal female foot was four inches long. This barbaric practice wasn't outlawed until 1911.

In the early 1900s, narrow feet were considered a sign of female grace and good breeding in the US and England. For those born with average (or larger) width feet, removing the small toe was an extreme option for the most desperate.

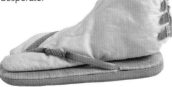

THE TABI SOCK
In Japan, shoes are for outdoors only so the Tabi sock and Zori sandal were created to keep feet covered indoors.

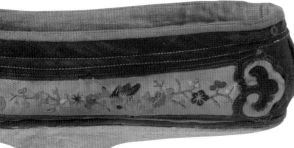

HOBBLING FOR ALL WOMEN
In the foot-binding days of pre-revolutionary China, Manchurian women weren't allowed to bind their feet. To copy the gait of foot-bound damsels, Manchurian ladies wore footwear with high pedestal soles.

KEEPING FEET IN PLACE
During the day, bound feet were kept in place by shoes like these (left), which, with their intricate embroidery, were actually rather beautiful. However, bound feet were hideously deformed, and once the binding process had started, the feet would never return to normal.

A touchy subject

Reflexology is increasingly seen as a way to maintain good health. How it works: certain small areas on each foot correspond to specific organs; pressing these spots can help correct a specific condition. For instance, press a spot in the middle of the foot's underside and you can stimulate a sluggish kidney. But what does reflexology have to do with shoes? The technique underlines how revered the foot is and how important feet are to overall health. Further, reflexology can celebrate gorgeous shoes by pairing up with a pedicure, that *de rigueur* service for the Manolo–Jimmy Choo crowd. Many beauty therapists incorporate reflexology into 'premium' pedicures as a way to stimulate circulation (to make your complexion glow) and relaxation (which you'll need after a day of wearing the Choos).

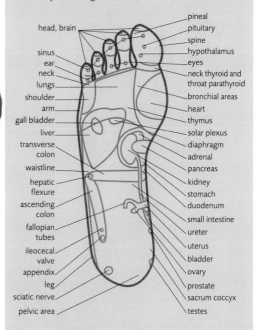

head, brain
sinus
ear
neck
lungs
shoulder
arm
gall bladder
liver
transverse colon
waistline
hepatic flexure
ascending colon
fallopian tubes
ileocecal valve
appendix
leg
sciatic nerve
pelvic area

pineal
pituitary
spine
hypothalamus
eyes
neck thyroid and throat parathyroid
bronchial areas
heart
thymus
solar plexus
diaphragm
adrenal
pancreas
kidney
stomach
duodenum
small intestine
ureter
uterus
bladder
ovary
prostate
sacrum coccyx
testes

Shoe fetish

Footwear can be downright sexy. Shoes emphasize the feet and can create suggestive toe cleavage, arched insteps and long, long legs. In fact, with such sensual appeal, is it any wonder that shoes, along with feet, have become objects of sexual desire?

Shoe fetishists can probably be split into two groups: those who hoard shoes – Imelda Marcos, anyone? – and those who view shoes as a sexual turn-on, be it by rubbing them, being stepped on by them, or just being turned on by seeing women in certain styles of shoe! For the latter group, it is often extremely high-heeled shoes that are most worthy of obsession, making stilettos and platforms hands-down favourites. These super-heels give the wearer a sex-centric, breast-forward, butt-back silhouette, while also elongating the calf to create a long, leggy appearance. (Interestingly, super heels are a favourite of female shoe-hoarders as well). Hard-core shoe fetishism may also dictate the material a shoe should be made of. Second-skin material such as rubber, PVC and patent leather are common turn-ons – creating a shiny, 'paint on naked skin' finish.

Getting the boot

Boots are often seen as more fetishistic than shoes. For most of us, boots are just

KINKY BOOTS
For the discerning shoe fetishist these boots have it all: high heels, long length and a sexy PVC finish.

VICTORIAN VAMP
Late-19th-century sex workers wore thigh-high lace-up boots for that added dominatrix effect.

WIGGLE AS YOU WALK
The higher the heel, the sexier the walk; that is until you take a tumble – not so sexy now, huh?

MAID TO MEASURE
Masters of shoe creativity, Thea Cadabra and James Rooke add extra sex appeal to their heels by modelling them on the legs of a sexy French maid.

Transvestite shoes

What do men dressing up as women choose to wear on their feet? Well, a surprisingly large number seem to love high heels, showy platform sandals in particular. High heels do not discriminate – they create the same girly saunter for men, which goes a long way in explaining the shoe's transvestite appeal. But there's more. Platforms are easier than stilettos for bigger-boned men to navigate in, and they're downright showy when done up in bright colours and exotic designs, making them an easy way to add fun to a wardrobe. Scores of companies have sprung up specializing in high, wide, men's-sized women's shoes like the ones here. Guaranteed to give any drag queen a sexy strut!

practical – they keep our legs warm in winter. But they can also send out messages of sex, power and dominance. High-heeled boots give a sexy swagger to your step – you're forced up onto the balls of your feet so that your breasts jut forwards, your hips sway for balance and your butt sticks out. If the boots rise over your knees, your movement becomes even more exaggerated.

Boots also coyly allude to the leg underneath, and thigh-high boots in particular draw the eye up towards the genitals – could this be why they have long been the trademark of prostitutes? The first acknowledged 'kinky' boots (with an obvious sexual connotation in the name) were designed in Europe for sex workers around the 1890s. These early 'sex' boots featured high – sometimes as high as ten inches – thin heels (these boots weren't made for walking, after all!) and a full leg's worth of button fastenings or lacing, for slow, deliberate removal. Worn by a dominatrix, there'd be no doubt who was the boss!

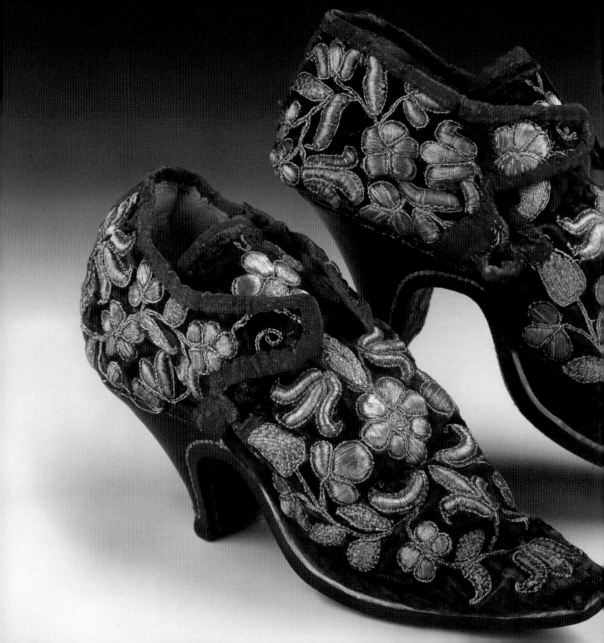

Shoes of Yore

For nearly as long as there have
been humans there have been
shoes, but what began as a
utilitarian way to protect feet
eventually evolved into shoes
made pretty for fashion's sake.
Witness the progression from
bark and animal skins to the
elaborate sandals of Egypt; the
sexually suggestive footwear of
the Middle Ages; Renaissance
high heels; the frippery of
France's golden age and the
confines of Victorian era boots.
Perhaps proof that, even then,
shoes lent the same air of
seduction, fun and mystery
to the wearer as they do today.

1 Pre-1900

The BC years (before cobblers)

One of prehistoric human's first inventions was string made from plant fibres that were twisted together to form twine. This string secured bark or animal skin to the feet for protection – the first shoe!

Although not a lot is known about prehistoric shoes, we do know from a Spanish Palaeolithic cave painting that footwear has been around for a long time. The painting depicts a man and a woman wearing furry animal skin boots. The art is believed to be between 14,000 and 17,000 years old.

The first moccasin

Early man used the skins of slaughtered animals for clothing, and eventually discovered how to tan and preserve them. Shoes were also made from animal skins to give better protection and keep the feet warm in colder climates. A piece of treated skin with holes inserted around the edges was put under the foot and laced using a leather strap that acted as a drawstring to hold the shoe in place. This was an early example of the moccasin shoe, still very common today.

The oldest known sandal

The most ancient footwear actually unearthed is a 10,000-year-old sagebrush-bark sandal, found in an Oregon cave, buried under layers of volcanic ash. The sandal's sole was made of grass and shredded sagebrush bark twisted into ropes, tightly woven together with thinner ropes. The rope was interlaced back and forth, leaving loops at the sides through which a tie string was drawn to fasten the sandal to the foot. Interestingly, the bottom of the shoe's sole was ridged for improved traction.

Ancient Egyptian footwear

Sandals were worn by ancient Egyptians from all social strata, although the poor wore simpler sandals that didn't probably didn't last very long. A popular style of sandal in BC Egypt was a thong-like sandal

EGYPTIAN SANDAL
This style of woven straw toe–thong sandal from ancient Egypt, circa 300 BC, was a very popular form of foot protection that was made from braided palm leaves and was probably stronger than it looks!

EARLY MOCCASIN
This pair of early moccasin-style shoes, called pampooties, shows the basic idea: a piece of animal skin with holes pierced around the edges, through which a drawstring was threaded to hold the shoe in place. The style survived in the Scottish islands into the 1800s.

On your feet

That we even need shoes at all may have everything to do with how we walk: bipedally, or in plain English, on two feet. But why are we the only mammals to do so? Did we stand to keep our hands free for throwing weapons and hunting game? To dress up in a flirty pair of hemp-woven, thong-strap sandals or smart-looking animal-skin moccasins? Put an anthropologist, biologist and shoe designer in a room and you'll get different answers. This is one mystery that may never be solved!

made of braided palm leaves, which were fastened to a bark, wood or leather sole on both sides of the ankle and between the first and second toes. A recent archaeological find was some ancient thong-like sandals that pyramid builders once wore. The dry sand of the Egyptian desert had kept them perfectly preserved. More proof that ancient Egyptians loved their shoes are the temple murals dating from 3000 BC showing shoes and shoemakers.

In early Mediterranean and Middle East societies, sandals with toe-straps – also called thongs – were popular. The big toe anchored the sandal, just as it does today. Simple but very effective.

ROMAN SANDAL
This sandal, known as a caliga, dates back to AD 100–200. The leather upper has had pieces cut out to form thin straps. It certainly bears a resemblance to some styles of modern sandals.

The crackow

European history is littered with examples of clothes worn by royalty that have gone on to influence the fashions of the affluent classes. When it comes to shoes, the story of the crackow during the Middle Ages is a prime case!

This isn't to say that royalty always had the final word on style. Far from it – many kings and queens of the past have had questionable taste in fashion! What would often happen, though, was that a new style of clothing would appear on one of Europe's city streets. One of three things would then occur: the clothing would either disappear without trace, become fairly popular, or – the ultimate accolade – be picked up on by those in royal circles. Word would then spread quickly among ordinary citizens that this latest apparel now had the royal seal of approval. People then wanted to copy the style in an attempt to emulate the nobility. You could say that royalty were like the movie stars of today – worshipped and adored.

Enter the crackow

And so it was that the most amazing (and amusing) footwear trend of the Middle Ages – the crackow – kicked off in royal circles. Thought to be of Polish descent, the shoes began life as a pull-on slipper for men, but as their popularity grew, so too did their size. As the Middle Ages progressed, and people grew increasingly concerned with status, the slippers changed into shoes. And over a 30-year span, the end of the shoe grew. And grew. And grew, until

GOING CRACKERS!
Social rank dictated who could and couldn't wear crackows. The higher your status, the longer your pikes could be.

MAKING A POINT
The crackow is believed to have originated in the old Polish capital of Krakow, although the shoe has several variant spellings.

How shoe sizing began

Edward II set out shoe sizes in 1324.

- He decreed that three barleycorns, placed end to end equalled one inch.
- 36 barleycorns, end to end, were the length of his own foot.
- Each barleycorn was one-third of an inch, which added up to 12 inches or one 'foot'.
- The longest normal foot at the time measured 39 barleycorns, or 13 inches, and was called size 13.
- Smaller sizes were graded down from this number, each by a third of an inch.

sometimes the ends (called pikes) became so long that they eventually included a chain that attached the toes to the knees to keep men from falling over! Younger men stuffed the ends with wool, wads of cloth, or moss to keep them erect. Some mischievously painted the pikes a flesh-colour so that they resembled a penis. Others attached small bells to the ends, which purportedly indicated a willingness to 'frolic'. 'Footsie, footsie', some men would whisper to female passers-by, while picking up a foot and wagging it towards the women.

The crackow edict

The phallic shape of the crackow caused a bit of a tumult. Scholars were forbidden to wear them, as were clergy. The Roman Church attempted, through sermons, threats and sumptuary laws, to stop the remaining ribaldry, going as far as blaming the shoes for the Black

Death (God's curse) of 1347. Edward III of England, who reigned from 1327 to 1377, had some success in limiting who wore the shoes by introducing an edict stating that only royalty could wear their shoe tips as long as they liked. Knights were limited to one-and-a-half feet, landowners to a foot, and lowly commoners to six inches. Those who earned less than 40 pounds a year weren't permitted to wear them at all! The crackow's popularity finally waned after it is said that Duke Leopold II of Austria died when his long, pointed shoes impeded him from escaping his assassins. The nail in the crackow's coffin was a new shoe style: wide and relatively comfortable, thanks to France's Charles VIII and his polydactylism (he had 12 toes).

A new design

Patten shoes, also known as clogs or galoshes, were another popular style of the Middle Ages. The shoe was a wooden block (later made of metal) attached to a delicate slipper. The overshoe was worn outdoors to protect indoor shoes from mud and rough stone pavements.

A FIGHTING CHANCE
Despite their chivalry and prestige, medieval knights had to restrict the pikes on their crackows to *only* one-and-a-half feet...as if their clunking armour wasn't cumbersome enough!

'High' Renaissance

In the late Middle Ages, Florence is considered the style capital of the world, but it is in Venice that chopines – unbelievably high platform shoes, usually wooden, with super-long heels – are especially popular.

Chopines frequently measured a staggering (quite literally) 24 inches or more, meaning an escort or walking cane was essential. Stunned visitors to 15th-century Venice would exclaim, 'Outrageous!', 'Immoral!' and 'Shoes of Satan!' as they witnessed the teetering, chopine-wearing locals. One shocked onlooker went as far as to write that the chopine 'must have been invented by jealous Italian husbands who hoped that the cumbersome movement it entailed would

HIGH MORALS
Surprisingly, the Church actually approved of chopines because they prevented women indulging in 'sinful' activities such as dancing.

make illicit liaisons difficult for their wives'. Some costume historians believe that chopines started life as wood-bottomed overshoes with velvet uppers, worn outdoors to keep the wearer's good shoes clean and dry. And the city's famed courtesans may well have added a little extra height to their overshoes in an effort to make themselves more conspicuous as they waited in dark doorways for potential customers.

The haves...

The royalty and wealthy women of Florence were the first to don chopines as fashion items. And soon aristocrats in other countries were also tottering around on them. In time, men adopted the look, too. The French were especially enamoured with the style, which may have entered 16th-century Paris on the feet of Catherine de Medici, who arrived in the capital to marry the king. Soon, most of the palace were mincing around and taking frequent tumbles. Eventually, however, French women were banned from wearing chopines, which were blamed for everything from miscarriages to adultery.

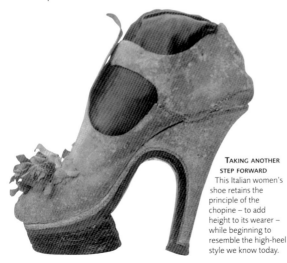

TAKING ANOTHER STEP FORWARD
This Italian women's shoe retains the principle of the chopine – to add height to its wearer – while beginning to resemble the high-heel style we know today.

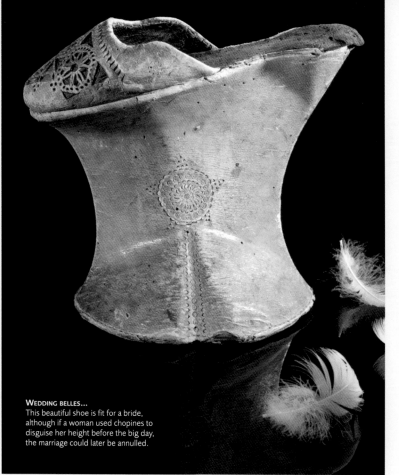

> *" By'r lady,*
> *your ladyship*
> *is nearer to*
> *heaven than*
> *when I saw*
> *you last, by*
> *the altitude*
> *of a chopine. "*

FROM SHAKESPEARE'S HAMLET

WEDDING BELLES...
This beautiful shoe is fit for a bride,
although if a woman used chopines to
disguise her height before the big day,
the marriage could later be annulled.

...and the have-nots

The well-heeled aristocracy of 16th-century Europe looked down – literally – from upon high over the flat-footed masses. Chopines weren't fit for farmers, milkmaids or even the waiting staff of the most distinguished families. Not only were the hoi polloi forbidden to wear heels (sartorial rules dictated what poor people could wear), such shoes would have made it impossible for these folk to earn a living. The rich could barely move in chopines without leaning on their canes or attendants; just imagine trying to chase after goats or scrub castle floors while sporting such impractical footwear!

The royal heels

The craze for height is on the way down. By the end of the 17th century, chopines have died a slow death and have been replaced by much lower, often-patterned heels.

Seventeenth-century history buffs will already know how important fashion was during this period; men in their leonine wigs, powdered faces and coloured silks, and women with their high hair and impossibly wide-hipped panniers (a hooped framework to extend the dress).

Trade routes continued to open up, further enabling wealthy Europeans to share in what other countries were wearing. As Louis XIV was crowned in 1661 and became renowned for his exquisite taste, the French court grew more influential in the fashion stakes. Louis, who wanted to look taller, grew fanatical about his heels, banning anyone other than the privileged classes from wearing them, upon penalty of death! He was especially keen on red heels, which became associated with high social status. Heels were often decorated with detailed rustic patterns, although battle scenes and seductive portraits of the wearer's lover were both fashionable alternatives.

A MULE WITH A KICK
Now this is a pair of mules! Again, note the decoration on the heels, so typical of the 17th century.

The Louis heel

By the time Louis XV came to the throne in 1715, heel shapes had become more adaptable; hourglass shapes were popular, as were carved designs. Shoemakers to the royal court created a curved heel that was covered with the same material as the rest of the shoe. It turned out to be very popular with the king – today we know the shape of this heel as the Louis heel.

A TOUCH OF THE ORIENT
Many 17th-century shoes had the heel covered in the same material as the upper, as this English silver and blue brocade tie shoe shows.

Slippers as shoes

Most 17th-century shoes were either slippers (often held onto the foot with a ribbon tie), mules or high-heeled 'loafers', for lack of a better word. Both men's and women's shoes were similar, save for the brighter colours and greater intricacy of men's. Both men and women preferred a more square toe but by the end of the century women's toes became more pointed due to changing notions of femininity. Boldly patterned cloth, embroidery, jewels (faux and other-wise), bands of metallic braid, pretty ribbons and other frippery could be used to gussy up ladies' footwear.

Cinderella's slippers

We all know that Cinderella got her prince by losing a glass slipper. However, according to some, Cinderella's original slippers were made of warm, cuddly fur and didn't become glass until an inept English translator mistook the French vair (fur) for verre (glass)! Slippers may not be your thing but you can still use your shoes to lure your own Prince Charming. Find something unusual – preferably one-of-a-kind. Make sure it flatters your foot (nothing that will make your foot look overly large or boxy), and matches your outfit. Lastly, leave one of the shoes where the man can find it. If he's the prince you think he is, he'll return it personally.

LAST OF THE GREAT CHOPINES
Chopines hung on into the early 17th century. This replica pair of green velvet and gold brocade chopines from the early 1600s, combine height with style.

LIKE A FINELY MOWED LAWN
Reminiscent of those old candlewick bedspreads (your granny probably had one), this green latchet tie shoe with Louis heel from the late 1600s was made from satin and has appliqué of a fine plaited braid.

A WORK OF ART
Made of blue velvet and embroidered with silver gilt thread, these shoes were probably worn for a special occasion.

" Better be out of the world than out of the fashion."

OLD ENGLISH SAYING THAT FIRST APPEARED DURING THE MID-17TH CENTURY

Buckle up!

In the 18th century, pointy toes are the 'in' look for shoes, with gorgeous silks and brocades being used in their design. The big shoe accessory is the buckle, a metal fastener that doubles as a fetching decoration.

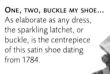

ONE, TWO, BUCKLE MY SHOE... As elaborate as any dress, the sparkling latchet, or buckle, is the centrepiece of this satin shoe dating from 1784.

Ah, the 18th century, a period crammed full of activity. The French had their revolution, as did the Americans. Thinkers such as Voltaire and Rousseau were busy figuring out the world, and new gadgets such as the flush toilet and thermometer were being invented.

As for shoes, stockings became the accompaniment of choice for most shoes. The moneyed classes favoured silk, machine-knit stockings, while working-class men and women knitted their own hosiery (often of wool).

BUCKLING THE TREND
Base metals – brass, steel, wrought iron, spelter or bronze – were the material of choice for the buckle creator. The beauty of these designs is in stark contrast to their severe-looking locking bars.

Shoe sophisticates

Up until this time, men were the ones who wore the most elaborate shoes, but it was now acceptable for upper-class women to surpass men's shoes in ornateness. These ladies wore brocade/damask shoes, but changed into leather for the country. Ladies often wore mules (referred to as house shoes) indoors or pull-on shoes with heels. (Incidentally, female workers wore leather shoes that were barely more feminine than those of their male counterparts.) The most popular way of accessorizing shoes was with a buckle, which also served to adjust the size if needed.

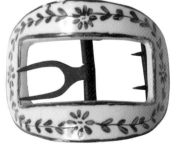

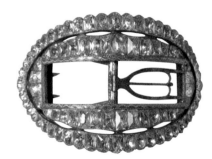

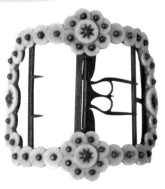

Clog overshoes

Sharing many similarities with chopines and clogs, pattens were a godsend to men and women of the 18th-century nobility in caring for their highly decorative shoes. Made of wooden soles with leather uppers or straps, pattens kept the feet dry and free from mud and dirt. The soles often had nails hammered into them to provide more traction – just imagine the clatter of the bustling, cobbled streets!

From buckles to laces

These buckles were akin to jewellery; both men and women had elaborate pieces constructed for their shoes and regularly updated their footwear with new additions. Along with silk stockings, the ornate buckled shoe is one of the fashions that we most associate with the 18th century. Yet in 1790, something happened that would eventually have men retiring from their buckles for good – the shoestring was invented by Harvey Kennedy in Oxford, England. At first, critics called the laced shoe 'effeminate', preferring to stick with jewelled buckles, which to the modern eye, at least, look much more feminine than laces! But the more comfortable and supportive shoes eventually caught on, and the affinity for laces progressed into the next century. The fashion for deluxe silks and brocades also started to fade, to be replaced by longer-wearing leather. An era of more 'sensible', sombre shoes was emerging.

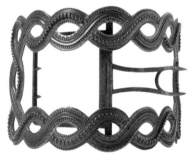

The Victorian influence

Though styles slowly change towards the century's end, Queen Victoria's black Balmoral boots remain the height of Victorian fashion, perfectly complementing the era's tight-laced fashions.

THE BOOT
This otherwise standard Victorian boot features buttons and elastic sides as stylish alternatives to laces.

Queen Victoria, mother of the British Empire, reigned for 64 years. Her strong personality influenced everything from social to sexual mores. She also held firm opinions on fashion, inspiring her own subjects and citizens of other countries to 'dress with gentility'. In other words, to adopt body-restraining, skin-covering fashion that was so uncomfortable, so impractical, that it tested the wearer's stoicism (a much-loved Victorian attribute).

STYLISH AND COSY
These rather attractive black (of course!) quilted carriage boots were padded to help keep out the cold when worn in the open carriages of the day.

Keeping flesh under wraps

What to wear with such modest garb? Black boots, the most popular choice of footwear during the Victorian period. These sturdy shoes were an attempt to keep women's calves and ankles under wraps should a stray crinoline, with its easily tilted hoop, fly up. (Hence the view we often have that men became overexcited when they glimpsed a flash of flesh beneath a heavy, long skirt.) Paired with the *de rigueur* corset of the day...

Fit for a Queen

Queen Victoria married her cousin, Prince Albert, in the Chapel Royal, St James's, London, on 10 February 1840. With her white satin dress trimmed with Honiton lace (a Devonshire town famous for making lace for the Royal family) and lace veil, she wore flat slippers of white satin, trimmed with bands of ribbon. Long ribbon ties fastening round the ankles held the shoes in place. They were made by Gundry and Son, 'Boot and Shoemakers to the Queen'.

well, let's just be thankful we live today, when we can get dressed by ourselves, and in under an hour!

Also popular was the Balmoral boot, a closed front ankle boot with a galosh. It got its name from the royal Scottish castle that Queen Victoria and her husband Albert often visited. Victoria was definitely a boot fan; boots were perfect not only for busy, do-good Victorian ladies, they were also less sexy than slippers, mules or – God forbid – open-toe shoes. In addition to the expected black leather, boots were worn in ivory silk, satin or brocade for weddings, and deeply coloured velvet for balls.

POSH SHOES OF THE 1800S
Whether made from kid leather or satin, the gorgeous embroidery and embellishments on these slip-on shoes transform them into quite beautiful creations for balls and evenings out.

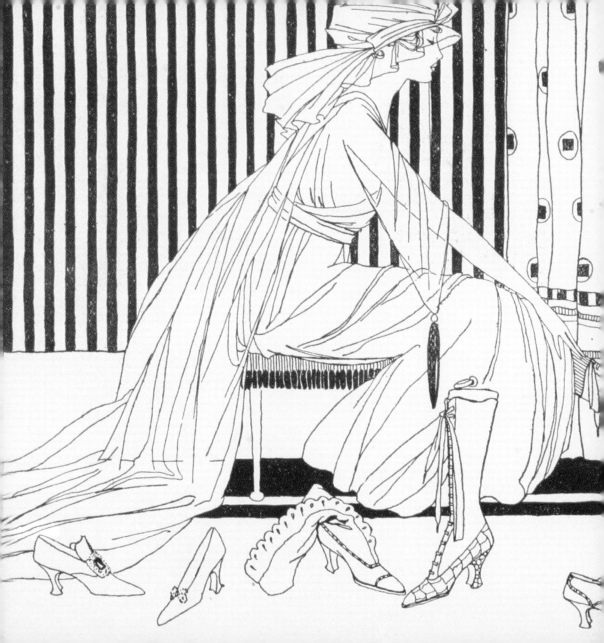

La Belle Époque

For centuries, shoes were a luxury: expensive, handmade and worn by the lucky few. But by the turn of the 20th century, emerging factories meant cheaper shoes, and affordable, fashionable footwear was suddenly accessible to everyone. World War I further shaped shoemaking as creative designers turned to various types of cloth uppers instead of leather and perfected a rubber sole. It's thanks to mass-made footwear that shoe lovers like yourself can today collect such a variety of athletic, dress and casual shoes, while still, occasionally, splashing out on beautiful bespoke.

2 *1900–1919*

Small is big

1904

The cult of gentility continues under Queen Victoria's son, Edward VII. As if waists sucked in by tight corsets weren't enough for women to bear, along comes the narrow foot craze.

This unfortunate new trend was fuelled in part by the Gibson Girl, who embodied femininity in the early 20th century. This fictional, idealized 'genteel female' had an hourglass figure, expertly upswept hair, a decidedly aristocratic air, lots of leisure time and a disinterested good humour. Women throughout America tried to reinvent themselves in the Gibson Girl's image, forgetting that 'the Girl' wasn't a real person, but a cartoon character of sorts illustrated by Charles Gibson. Even her minuscule feet were taken to be a sign of good breeding and gentility, and living females who couldn't recreate the same look felt unfeminine.

Extreme measures?

With small feet much in vogue, both men and women often wore shoes that were a full size too small, but some larger-footed females, desperate to avoid the clumsy, aggressive and peasant-like connotation of bigger feet, were rumoured to have had their little toes removed. Could this really have happened? If so, it couldn't have been that common because surgery (and anaesthesia) hadn't been perfected in 1904!

Shoe spells

The Gibson Girl was so confident she could presumably get any man she chose. For those not so lucky in love, these footwear spells may help you get your man.

Before bed, place your shoes in a 'T'-shape (heel of one against instep of the other) and say: 'Hoping this night my true love to see, I place my shoes in the form of a 'T'. Then slide beneath the sheets and dream of your husband-to-be.

Tuck a sprig of Southernwood fern in the right big toe of your shoe before leaving the house. You will marry the first single man you meet (watch out for the milkman though).

If you know who you want, but he doesn't feel the same, try this old Voodoo spell. Wrap a lock of the guy's hair (sorry, the Voodoo priestesses offer no advice on how to obtain this), in a piece of cloth and fold it as small as possible towards you. Put the bundle in your right shoe under your foot's arch. Repeat daily until your man begins to follow you.

More likely was the common practice of greasing feet in order to cram them into a pair of too-narrow (and often too-short) shoes.

Day shoes were usually boots. Evening shoes varied a bit more, with the most popular style being a court shoe with a small heel. These shoes were often embellished with embroidery or metallic thread, and glass beading in the toes – usually the only part of the shoe peeking out from a very full skirt.

Production-line shoes

Many folk, especially men, often had only one pair of shoes that lasted for several years. Until the 20th century, shoes were expensive and not always easy to find. Even those ugly, utilitarian creations required a decent amount of cash. In the early part of the 1900s, however, all this changed, thanks to factories that replaced slow, expensive humans with machines, churning out shoes more quickly and affordably than ever before. Interestingly, by 1909, almost four times as many Americans worked in factories than a generation earlier.

THE GIBSON SHOE
This style of Derby shoe with wide laces, here made of black patent leather and fawn suede, was known as the Gibson, named after the popular Gibson Girl, and had a long narrow toe called a duck-bill toe – you can see why!

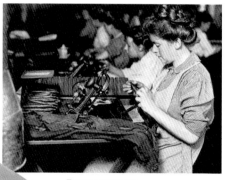

THE PRODUCTION LINE
The start of the 20th century saw shoemaking change forever with the emergence of shoe factories – more and cheaper shoes for all!

EVENING SHOES
These yellow satin bar shoes from 1905 are embroidered with gilt beads. The unnaturally narrow shape was the fashion of this period.

The first modern shoe designer

1910

Although Victorian boots are still popular, glamour is on the rise, with Elizabeth Arden's first beauty salon opening in New York and the emergence of an influential new shoe designer.

The black boots Queen Victoria made famous remained incredibly popular. In fact, the length of these boots reached their apex in the years 1909 to 1913, climbing to mid-calf! But as clothing was to slowly evolve, so were shoes, and about to hit the fashion scene was the first recognized shoe designer, the elusive Pietro Yantorny.

Top-tier luxury

Yantorny has always been a bit of a mystery. We do know that he was born in Italy in 1890 and as an adult lived in Paris. He became curator of the shoe collection at Musée Cluny in Paris. On the side, he designed shoes; sumptuous, fussy, unbelievable shoes, which could take two years to make, and for which he charged exorbitant fees. 'The most expensive custom shoe-maker in the world,' the sign outside his Paris salon claimed. Fashionably exclusive, richly decorated and beautifully light, the shoes were objects of desire.

One of his most loyal ladies was millionairess and socialite Rita de Acosta Lydig. 'A shoe without sex appeal is as barren as a tree without leaves', she said. She certainly believed it, as

HIGH FLYERS
Although staid black boots retained their popularity into the 20th century, they were on the decline. Now boots were brighter, bolder and higher, often reaching as high as mid-calf.

THE FEMININE TOUCH
Suffragettes needed sturdy footwear for their campaigning yet wanted to fight their opponents' stereotyping by remaining feminine. These button boots in suffragette colours would have been perfect for the task.

Shoes with sex appeal

You're on a night out and look a million dollars, but as you walk out the door, the shoes on your feet are more than a mere accessory.

Spike-heeled stilettos: you love being in control and will use your sexuality to be the centre of attention. Completely unpractical, you're probably clutching an unsuitably tiny bag to match.

Kitten heels: a more, low-level, Marilyn Monroe and her wiggle, kind of sexiness. You are effortlessly feminine and flirty, and love the way the little heel accentuates your tiny, but curvaceous frame.

The Mary-Jane: everyone's friend, you are ditzy, adorable and in touch with your inner child – an Annie Hall-era Diane Keaton.

The sensible loafer: the designated driver, you are practical, pragmatic and, oooh, just a little bit boring. Are you secretly a closet thigh-high fetish boot fan? We hope so!

A NIGHT TO REMEMBER
Although the top of the shoe (the vamp) remained high, Edwardian ladies showed a bit more ankle in the evening, leaving their boots behind and dancing the night away in beaded Cromwell-style beauties like these.

the acclaimed lady – a favourite of French artists – owned over 300 of Yantorny's handmade creations.

Pietro Yantorny's richly romantic shoes were keenly sought after by many women, but only worn by the elite. Some of his shoes survive in fine museum collections throughout Europe and in New York. Although modern shoe designers, including Manolo Blahnik, cite Yantorny as inspiration, no-one seems to know what happened to him.

THE SEEDS OF THE 'SHOE TREE'
Given that Yantorny's exquisite shoes could take up to two years to make, it's no wonder he wanted to keep them in good shape. Not content to do anything by halves, his shoe trees (like the one here) were made out of recycled violins.

War on waste

1914

As women join the war effort, comfort and practicality are paramount and lace-up boots come back into fashion. Female shoes become nearly indistinguishable from men's.

The outbreak of World War I in 1914 not only affected how shoes were manufactured, but also how they were bought, what they looked like and what they were made of. As the young and middle-aged males of Europe and America left to fight, women stayed behind, working in the traditionally male factory jobs.

WAR-TIME waste brings the woeful want. Eliminate the waste at the (private and commercial) car wheels. Fit WARLAND DUAL (quick-tyre-change) RIMS. No levers. No labour. Time saved. Tyres saved. The one indispensable accessory for the lady driver— WARLAND DUAL RIMS, Aston, Birmingham; 111 Great Portland Street, London.

BEHIND THE WHEEL
During World War I women had many more opportunities to drive. This necessitated practical footwear with low heels.

Unexpected freedoms

This new role for women spawned a trend towards comfortable, utilitarian shoes. Women were on their feet all day, there were no men to look girly for – why not wear those clunky Oxfords? Indeed, even men's trousers, jeans, socks, shirts and hats seemed a sensible idea.

Interestingly, it was the women in the military as non-combat personnel – telephone operators, nurses, army secretaries – who were pigeon-holed into more feminine garb. In addition to the *de rigueur* skirt, jacket (or cape!), hat and gloves, most wore a pair of black or brown leather ankle boots with a squarish heel.

Scarcity is the mother of invention

To further conserve valuable leather, soles were replaced with rubber. All-cloth shoes appeared on more and

WARTIME STYLE
These war-period Oxford shoes with Louis heels were a popular style that remained in vogue for another 30 years.

MUM'S ARMY
When it came to service shoes, comfort was the first and last consideration, and all boots had to be up to the knee.

One small step for man

Women may have been wearing the trousers, but when it comes to judging a man, it's all about studying his shoes.

Expensive trainers: a guy with funds to spend on sports shoes is a man who can afford to buy you dinner, drinks, and so much more.

Lace-up Oxfords: black equals a proper job, reasonable income and a semblance of fashion sense, although he could be a tad self-absorbed. Brown suggests an all-round nice guy, who believes in romance, marriage and family.

Cowboy boots: a sex-loving, testosterone-driven stud. Completely unbothered by the fact that cowboy boots look ridiculous outside the American west.

Biker boots: is he a Hell's Angel? How fun can it really be to ride behind a stringy-haired biker and be called his 'old lady'?

Flip-flops: worn anywhere other than the beach and he's a man who needs a lot of attention. Probably gives great massages, though, and knows about tantric sex.

more feet. At this time, however, people felt the need to pretend their cloth shoes were made of leather – who wanted to feel more restricted than they already were? So all-canvas or gabardine footwear was usually coloured in rich, leather-mimicking shades of brown.

Many women had only one pair of dress shoes during this time, usually court shoes. Making do with what one had was a common theme and women began using clip-on buckles, faux jewels and other ornaments to give their footwear different looks, depending on the outfit. This 'accessorizing the shoe' routine worked, perhaps, because most women weren't doing much dating and didn't have to worry about men's opinions!

Shoe round-ups

A change in style wasn't all that happened to shoes during the teen years of the 20th century. In the UK and the rest of Europe, and to a lesser extent the US, shoes were collected as part of the war effort and were either taken apart and reworked as something usable by the military, or sent to the men on the front lines, or even to those badly affected by war in continental Europe.

" *While the boys are away, we work for victory.* "

POPULAR WW1 SAYING AMONG AMERICAN WOMEN

Shoes get sporty

1916

The popularity of exercise and amateur sports grows. Walking, tennis and basketball are especially popular, prompting the creation of Keds and Converse sport-specific footwear.

Sport, in all its many glories, has been enjoyed for thousands of years, but it wasn't until the beginning of the 20th century that the idea of sports shoes really took hold. In 1916, the US Rubber Company designed and distributed Keds – marketed as canvas-top 'sneakers' because the rubber soles made them quiet – a comfortable shoe designed specifically for sport and exercise.

Keds make their mark

Little known in the UK but huge across the Atlantic, Keds were a sleeker-looking first-generation descendent of the plimsoll. Early Keds didn't look like the white trainers US consumers are used to seeing today; they had brown canvas uppers with black rubber soles, and were marketed exclusively at men. By the early 1920s, however, both sexes were wearing them. Donned by Olympic soccer players, scores of national and international tennis champions, and many college athletes, Keds were coined the 'shoe of champions'.

Seeing stars

In 1917, the world's first shoe designed especially for playing basketball hit the market – the Converse All Star, produced by Marquis M. Converse's Massachusetts-based company. Available in black or white canvas, and dubbed 'high-tops'

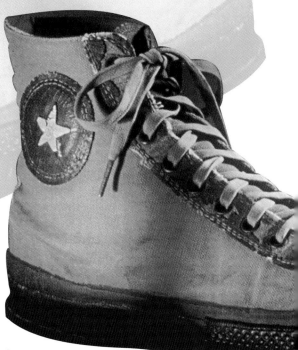

READY FOR TAKE-OFF
In 1917, the world's first performance basketball sneaker, the Converse All Star, was born. The game was changed forever.

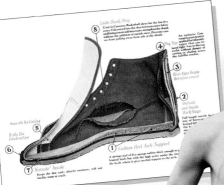

CONVERSE CONSTITUENTS (FAR LEFT)
The trade secrets of a design classic are revealed in this illustration of the All Star. Comprising eight unique features, would-be imitators of the shoe were destined to fail.

because of their ankle-high cut, Converse All Stars were rubber-soled and the early rival of the US Rubber Company's Keds. The All Star was known as the shoe that put the squeak into basketball. Six years later, in 1923, the shoe took on a new identity when basketball legend Chuck Taylor (right) put his name to it.

In the 80 years since, Converse has enjoyed incredible success. From customizing its shoes for the first all-African-American professional basketball team in 1923, to designing the A6 Flying Boot worn by the US Army Air Corps in 1942, to being an official sponsor of the 1984 Olympics, the company has stayed on top of its game. It has also stayed true to its original concept – to produce a comfy sports shoe.

Chuck Taylors

Up until the 1980s, when hi-tech sports shoes such as Nike Air appeared, Converse All Stars were the shoe of choice for basketball players, whether they were professional or amateur. And yet, All Stars – known as Chuck Taylors from the moment in 1923 when the basketball star's signature appeared on the shoes' ankle patch – were also cult classics among music fans, arty types and any other appreciators of their cool, timeless design and comfy fit. The punk stars of mid-1970s New York wore Chuck Taylors; see for yourself – check out almost any album cover for Blondie, the Heartbreakers, the Ramones or Television and you'll see All Stars pictured on at least one of them. Never really ever going out of fashion, in 1991 Nirvana's Kurt Cobain and other grunge musicians gave Chucks an even greater profile by sporting both high tops and 'low-rise' Oxford styles. And although today the likes of Nike and adidas may dominate the world of sports footwear, more than 750 million pairs of Chuck Taylor All Star shoes have been sold in 123 countries since its debut in 1923.

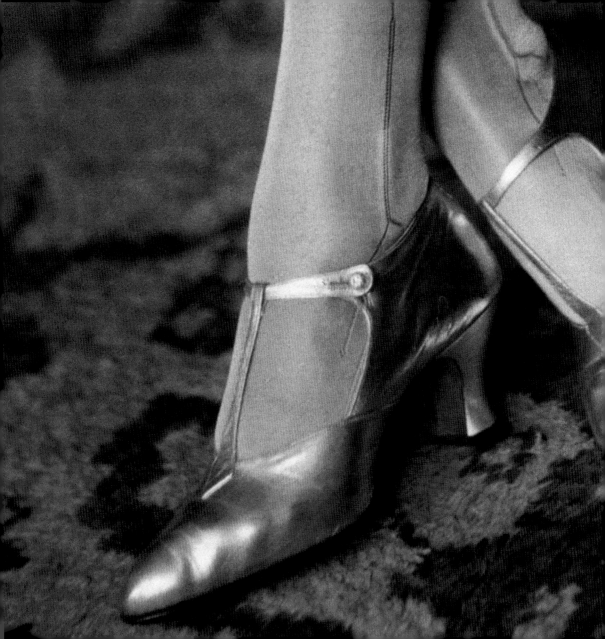

The Jazz Years

For women and their feet, this period was pure excitement. Fashion was showing more and more leg, placing a new focus on fabulous-looking shoes. In the 1920s, flapper girl vogue meant low-heeled, closed-toe 'dancing' shoes, while, despite the widespread deprivation, a new breed of celebrity-inspired glamour in the 1930s made shoes a sought-after luxury. For perhaps the first time, a legion of heel-obsessed fashionistas, paired with celebrity-driven footwear trends, teamed up to create the now familiar modern mania for eye-catching shoes.

3

1920–1939

Shoes on show

1920

Dissatisfaction with the older 'war-mongering' generation and prohibition leads to an active and rebellious youth culture – clothing soon becomes more casual, with ever-rising hemlines.

Full of optimism, naughtiness, originality and dazzling style, the 1920s was the first 'modern' decade. For the first time, women were enjoying freedoms unknown to their mothers – both American and British women could now vote, smoke, drink (forbidden cocktails in speakeasies in the prohibition-enforced US), swear and talk openly about sex.

Happy steps

It seems appropriate, then, that clothing lost its constrictive, formal, hide-the-flesh quality. Largely because of the war, women were used to dressing more comfortably and in more masculine clothing. Thankfully, no-one was returning to those tightly laced Victorian years. Instead, shorter, more

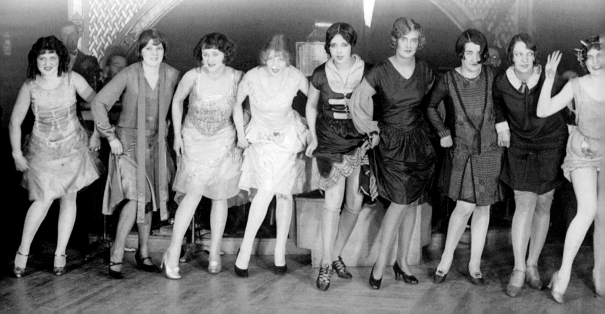

THE T-BAR SHOE
Dancing created a demand for a
very specific kind of shoe, namely
a T-bar pump with a sturdy,
medium heel. The 'T' over
the instep was often
made with a contrasting
colour or fabric.

naturally draped skirts were fashionable and, in some
instances, women even wore trousers in public, much to
the consternation of more conservative members of society.

What did all this mean for shoes? Well, the rising hemlines
made women's shoes more immediately visible. Consequently,
women took greater pains to match footwear to outfits.

PUT YOUR RIGHT LEG IN, LEFT LEG OUT
Dancing was *the* craze of the early
1920s, and dance marathons like
this one were events people attended
every weekend. Don't forget that there
were no movies or TV sets yet,
although the first 'talkie'
was just around the corner.

Women, shoes and men

Women were now free to dance the night away in
their new footwear, but did they ever wonder if men
were like a pair of shoes? For example, we buy shoes
that don't fit, hoping they'll magically change in time
– like men. We wear styles that we don't really like
because of social pressures – ditto men. And we
moan that shoes hurt us but don't do anything about
it. The same, of course, could be said of men...

Leather was making a comeback with war rationing over, but
cloth shoes were still very much in vogue, especially in satin,
brocade and other sumptuous textiles. Contrast was also a
1920s favourite, with maybe a different
coloured toe box, instep, strap or
whimsical design flourish.

Shoes galore

Many women, even younger women,
could now afford to own several pairs
of shoes, selecting styles on their
looks as well as their practicality; for
instance, shoes for walking, tennis,
golf or dancing. And multiple shoe-
ownership became much easier,
thanks to ever-improving factory
manufacturing, which made
footwear more affordable and
more available to a larger number
of people than ever before.

THOMAS & SONS
6 BROOK ST., W.1

Specialists
in
Women's
Sporting
Attire

THE NEW
"PLUS FOURS"
GOLFING SUIT
Made in a variety of
artistic Tweeds tone
band alike
PRICE FROM
12½ GUINEAS

SHOES FOR ALL OCCASIONS
Part of women's new-
found freedom was being
able to play sport, and
ladies could still look
the part in lower heels
designed especially
for the golf course.

Put on your dancing shoes

The most popular activity in 1920 was dancing. In the pre-war
days, dancing had been limited to private balls in upper-class
homes. Now people danced wherever and whenever they
could: in restaurants, at parties, in public dance halls (which
had started appearing just before the turn of the century); at
tea, after dinner, and on balmy Saturday afternoons, there
was dancing. People went to classes, they pored over
dancing magazines, and they shimmied along to the newly
broadcast radio music. The charleston hadn't yet hit the
dance scene, but the tango and shimmy were very popular,
as were couple dances based on the box step and waltz.

Walk like an Egyptian

1922

Tutankhamun's tomb is discovered. Filled with extraordinary treasure, including a solid gold coffin, a gold mask, jewellery and many artifacts, the discovery affects fashion design worldwide.

When archaeologists found the luxury-laden tomb of early Egyptian king Tutankhamun, the world was riveted, tuning into the fledgling radio broadcasts that began during this period to learn what the royal sepulchre could possibly contain. In addition to embalmed remains, there were untold riches: jewellery, baubles, art and objects of fantastic finery. This fascination resulted in a fashion flurry for all things Egyptian.

Janes and T-Strap shoes of the day with gold, something greatly associated with King Tut and the rest of his culture. Brightly dyed leather and bold, coloured fabric – often in fanciful prints – was also incorporated into shoes, mimicking the brilliantly shaded gems buried with the Egyptian king. Brocades, satin, silk and velvet were favourites, and were frequently enlivened with metallic embroidery, meticulous beading or sequins.

Upping the shoe tempo

As the world's collective imagination fell upon ancient Egypt, fashion designers incorporated bits of old Egypt into their wares. True, a sandal made of plant fibres was the shoe of choice for early Egyptians, but this was the Roaring Twenties. Nobody wanted plant fibre! Thus, fashionable shoes sported the designs and trappings of the rich and exotic culture. Designers gussied up the Mary

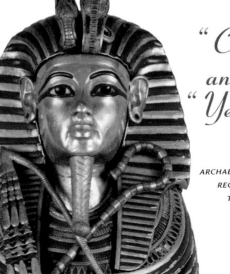

UNEARTHED RICHES
Part of the gold coffinette for holding the embalmed internal organs of King Tutankhamun.

" Can you see anything? " ... " Yes, wonderful things.

ARCHAEOLOGIST HOWARD CARTER, RECALLING HIS DISCOVERY TO LORD CARNARVON

TUTANKHAMUN INFLUENCE
Right: A selection of the most exquisite embellished heels from the 1920s, and left, a beautifully intricate brocade court shoe with jewelled heel designed by Frenchman Francois Pinet, who was clearly inspired by the new bold colours and shapes of the time.

Well heeled

The opulence wasn't limited to shoe uppers. Heels, typically mid-high and of the Louis style, were fashioned of Bakelite or embossed leather, and could be further embellished with anything eye-catching, from glass beads to rhinestones to animal skins to lace.

GOLD FOR ALL
The fact that this elegant gold and green kid leather bar shoe was available down your local cooperative store shows how far the King Tut influence reached!

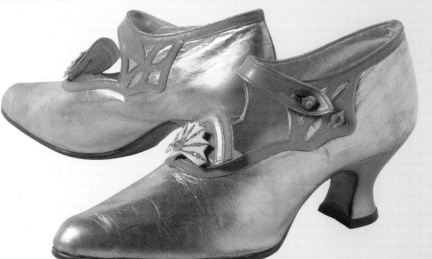

The charleston

1923

The popularity of the charleston, the dance of the trendy anti-prohibitionists, leads to low-heeled shoes with closed toes. The dance craze spreads throughout the Western world.

The charleston was characterized by outward heel kicks combined with an up-and-down movement achieved by bending and straightening the knees in time to ragtime jazz. The dance also required swivelling on the balls of the feet, balancing pigeon- toed, swaying the body side to side, and knocking the knees with the hands in a maddening frenzy! It was all too much for the clergy and other moral guardians of society, and it was banned in several American states for being too vulgar.

The charleston and shoes

The charleston could trace its lineage from the tribal dances of African slaves brought to America who settled around Charleston, South Carolina. Performed as early as 1903, the dance made its way into Harlem stage shows by 1913. The male chorus line danced and sang James P. Johnson's 'Charleston' in the musical *Runnin'*

Wild on Broadway in 1923. Both dance and song were expressive of the reckless daring, abandon and restlessness of the jazz-age flappers. Athletic and sexually suggestive, the dance required shoes that stayed put. Closed-toes were a must, as were lower heels. Soon, heels shrank an inch, and one to one-and-a half-inch shoes became the fashion for women. Two-toned footwear grew in popularity: for women, because it looked great with the foot-flying moves of the charleston, but also for men, who danced in two-tone spectator shoes.

DANCING SHOES
Charleston shoes had to have lower heels and closed toes. You can see why!

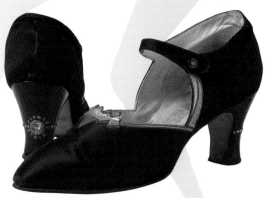

CLASSIC DESIGN
A beautiful black satin bar shoe with jewelled heels and decoration that is unmistakably 1920s.

the original charleston

MUSIQUE DE

Cecil Mack
et
Jimmy Johnson

dansé
par
Josephine Baker

DANS L'HYPER-REVUE
DES FOLIES BERGÈRE
"LA FOLIE DU JOUR"
DE LOUIS LEMARCHAND

de Valerio

Editions Francis Salabert
Paris . Bruxelles . New-York

JOSEPHINE BAKER
This was the publicity poster for *The Original Charleston*, the 1925 musical starring black cabaret star Josephine Baker, the controversial heroine of the flapper generation. With her uninhibited dancing and exotic costumes, she soon became famous for her overtly sexual stage shows as much as for the colour of her skin.

Art Deco elegance

Salvatore Ferragamo, shoe designer to the stars, returns to his native Italy and his custom-made shoe business becomes hugely successful, with shops opening all over the world.

ART DECO STYLE
Examples of Art Deco fashion: strong lines and contrasting colours.

Art Deco was one of the first important aesthetic movements of the new century. Rooted firmly in the world of visual arts, it embraced abstraction, distortion, simplification, geometry and bold contrasting colours.

A revolution in design

Art Deco influenced everything from building construction to furnishing, fine arts, jewellery and clothing. The movement got its start – indeed, its name, too – from the 1925 *Exposition Internationale des Arts Décoratifs Industriels et Modernes*, held in Paris, which celebrated 'living in the modern world'. Art Deco was for people in the know, the fashionable set, the cool of the mid-1920s who were ready to put every prissy Victorian and Regency reference behind them and embrace this new aesthetic with zest.

ART DECO SHOES
The style of these 1928 black satin bar shoes reflected a by now familiar Art Deco influence, but the heels continued to amaze!

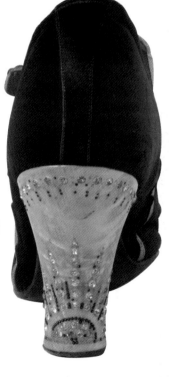

Calzaturificio di Varese

Filiali in tutta Italia

Architecture on a minor scale

Shoe designers were also quick to incorporate the styles into their designs. For example, it's impossible to look at Salvatore Ferragamo's innovative shoe designs without noticing the Art Deco architectural influence. Ferragamo experimented with a range of wedges, and with heels and platforms, in pressed and rounded layers, sculptured and painted, and decorated with small mirrors or brass grates in the form of floral spirals – styles we'd associate more with the spectacular architecture of the time such as the Chrysler building (right) in New York, for example.

A revolutionary designer

Born in southern Italy in 1898, Ferragamo travelled to America in 1914 to join his four brothers already residing there. He teamed up with one of them in a Boston shoe factory that made cowboy boots. But Salvatore's passion was for custom-made shoes. He was convinced there would be a market for them in California, and he persuaded his brothers to make the move west. After opening a shop for repairs and made-to-measure shoes in Hollywood, he started to make boots for actors in Westerns. He then began to design custom-made shoes for the biggest stars in Hollywood, such as Lillian Gish, Rudolph Valentino and Gloria Swanson.

A bold step

By 1927, however, Ferragamo realized that he couldn't meet the growing demand for his bespoke shoes without adopting the technology being used by the major shoe manufacturers. Rather than compromise the quality of his creations, Ferragamo made a courageous move: he returned to Italy with the dream of producing quality footwear for as many people as possible. Setting up his factory in Florence, Ferragamo employed the mass-production techniques he'd learnt from his time spent in the US and combined them with the craftsmanship of Italian luxury goods. Ferragamo was hot on the heels of worldwide acclaim.

OVER THE RAINBOW
This 1938 sandal made for Hollywood über-legend Judy Garland consists of gold kid bands, with the heel covered in different colour suedes.

SALVATORE FERRAGAMO SHOE GALLERY

CHECK MATE
Shoemaker to the stars, Ferragamo created countless shoes for the beauties of Hollywood, such as these red suede and gold kid sandals.

SEEING DOUBLE
Called an Anny pullover, this shoe was popular in the late 1920s. It features a double instep strap, and was designed for film actress Pola Negri.

Chanel's wearable luxury

It was into this exciting new vogue of stylish comfort that Coco Chanel's designs found an appreciative audience. Corsets were still fresh in women's memories – now they wanted modern! They wanted chic! Chanel's move-with-you fashions in Art Deco-loving colour combinations such as black and ivory, and navy and white, couldn't be more perfect. Flattering drop-waist skirts. Wide-leg trousers. A simple T-shirt. These were worn with a swipe of red lipstick, a golden tan, a sporty bobbed coif, and plenty of pearls, real or not!

The shoes were an integral component of the total look. Two-tone pumps were refashioned into comfortable, ground-skimming flats, and worn with just-below-the-knee skirts or trousers (only just coming onto the scene) for any occasion. Both were highly visible styles that drew attention to the feet in a way sensible shoes hadn't before. Suddenly women looked sleek, confident and so gorgeously capable.

COCO CHANEL
She brought us the little black dress, bell bottoms and No 5 perfume – the woman was a genius!

Coco Chanel

Born in 1883 in France, Gabrielle Chanel was born into poverty and raised by various relatives before becoming a seamstress. Determined to create a more prosperous life for herself, Gabrielle took the name Coco and became a café singer. Her fresh beauty and personal style – she favoured body-conscious outfits – attracted the attention of various wealthy men and she enjoyed the life of a well-kept courtesan. Two of her lovers helped fund her first design successes as a milliner. By 1916 she had parlayed her millinery skills into a blossoming clothing company for the wealthy.

> "*Luxury must be comfortable, otherwise it is not luxury.*"
>
> *COCO CHANEL*

WELL-HEELED
This elegant '50s number has three straps of black satin interlacing at the centre. The high stiletto heel is made of brass cage, and the slingback is made of black satin with suede reinforcement.

GOLD RUSH
These glamorous 1936 platforms were created for Brazilian dancer Carmen Miranda and are made from gold kid and luxurious black satin with a mosaic of gilded glass on the cork heel.

VAMPING IT UP
This distinctive shoe was made for screen actress Mary Pickford in 1924 and features a high vamp in red Tavarnelle lace and a delicate extended strap in gold kid.

Down at heel

1930

The Great Depression hits North America and Europe with shortages, high costs and extreme unemployment. People flock to the movies to escape into the glamour of Hollywood.

Although the Depression started with Black Tuesday – the Wall Street stock market crash in October 1929 – it wasn't until the following year that the full ramifications hit the US and Europe. The effects were devastating. Jobs were scarce, which meant money was scarce, as were consumer goods. Those items that were available were expensive.

Hard times

People who had never sewn, gardened or grown vegetables were now on the do-it-yourself track, forced to mend and patch last season's outfits, and grow and preserve their own food. Clothing was unsurprisingly utilitarian – no frills or bows or anything that used excessive amounts of fabric.

The birth of celebrity?

Many say the height of Hollywood glamour was in 1930, when 'talkies' really took off. People clamoured for the latest films so they could copy actresses' outfits, shoes, hairstyles and make-up. To further study celebrity wardrobes, they bought movie magazines, which were even more popular than they had been in the 1920s.

Toned-down shoes

As maybe you'd expect during hard times, no particular shoe style reigned this year; it was an assortment of flats, pumps (maybe decorated with a clip-on ornament, especially if the shoe was last year's model), mid-heel cutaway pumps with ankle straps, lace-up or buckled Oxfords feminized with a medium heel, and two-tone shoes made of leather and cloth. Most heels, if a shoe had them, were plain and a bit chunky – something practical and easy to wear. The one all-encompassing trend was a rounded toe.

CUTTING DOWN ON LEATHER
During times of economic hardship, shoe designers were forced to use more fabric and less leather. This 1930 fabric court shoe was available from Harrods.

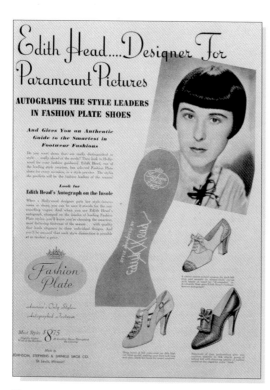

HOW TO LOOK LIKE YOUR FAVOURITE MOVIE STAR
Such was the growing popularity of film stars in the 1930s that Hollywood designers appeared in magazines such as *Vogue* to advise women what they should be wearing to look like glamorous movie actresses.

" Reckless spending is a thing of the past. "

1930 SEARS CATALOGUE

Hollywood glamour

Much more interesting were the graceful, pretty, eye-catching shoes designed to complement the mid-length skirts and elegant evening gowns shown in the movies. Musicals such as *Puttin' on the Ritz* helped people forget their worries and featured some of the year's most alluring costumes, including strappy dance sandals with rounded, often open toes. In the real world, these fanciful (costly) creations were for the well-off and saved for the evening, and typically interpreted in sturdy yet oh, so luxurious silks, satins, suede and kid. Among the most enchanting creatures of 1930 were Greta Garbo (in the year's first talkie, *Anna Christie*), Norma Shearer and Marlene Dietrich.

A TWIST ON THE TWO-TONE SHOE
This style had been around for some years, but the Depression produced a variation on the two tone: fabric and leather together.

Going for gold

1936

Jesse Owens wins four gold medals at the Berlin Olympics wearing designer trainers. He steals the show, his performance creating massive interest in his footwear.

An incredibly tumultuous time for the world: Spain was divided by civil war, several revolts occurred in Japan and Palestine, and the US was suffering from the Great Depression and a debilitating three-year drought. It was in Nazi-governed Germany, which had just forcibly reoccupied the Rhineland, that the 1936 Olympics took place.

Jesse Owens and the magic shoes

James Cleveland Owens was born in 1913. He developed a love of running in childhood but it was in high school that his athletic talent was noticed. Living in Ohio, Owens was

DAZZLING DASSLER
From designing the first spiked trainers to creating screw-on studs for football boots, Adi Dassler was always ahead of the game when it came to pioneering sportswear.

breaking a number of state and even world records at school, and went on to do the same at the state university. By the early 1930s, Owens was recognized as one of America's most gifted athletes.

In 1936 many Olympic athletes were wearing shoes by Adolf (known as Adi) and Rudolph Dassler, founders and owners of the Gebrüder Dassler Schuhfabrik company, but spectators were fixated by African-American Jesse in his German shoes. Owens' four golds brought even more attention to the footwear, and soon athletes all over Europe and North America were wearing the now-famous trainers.

The early years of adidas

A passionate athlete himself, Adi's vision was to provide every athlete with the best possible footwear. He created his first shoe in 1920 when he was just 20 years old and, in 1924, Adi and his brother Rudolph founded Gebrüder Dassler, producing track, field and other athletic trainers. Their shoes were an overnight success and were soon worn by elite runners and field athletes all over the world.

Puma

Rivalry in the Dassler family was intense, however, and in 1948 Rudolph, tired of playing second fiddle to his brilliant brother, broke away to form Puma, named after – you've guessed it – the fast wild cat. Adi renamed the original shoe company adidas and in 1949 added the three stripes, supposedly to offer extra support, which still identify the

brand. Rudolph's Puma found fame in 1970, when
Pelé wore Puma football boots in the World Cup finals, and
it remains a popular 'concept' brand today. adidas thrived,
patenting many of the sports innovations of the 20th century.
In 1954 Germany won their first soccer World Cup final
wearing boots with Adi's new screw-on studs, and in 1968
adidas trainers helped Dick Fosbury perfect his new high
jump technique. Adi Dassler died in 1978 but his trainers
are still worn by athletes and trendsetters alike.

OWENS OVERCOMES THE ODDS
Despite the games being held
in Hitler's Nazi Germany, Jesse
Owens, grandson of Alabama
slaves, became the star of the 1936
Olympics after winning four gold
medals. Owens also paved the way
for the likes of David Beckham by
becoming one of the first famous
athletes to promote sports shoes.

*" My dream is to make
the best shoe for each game. "*

ADI DASSLER

THE ADIDAS OLYMPICS

THE WORLD'S FASTEST SHOE!
In 1964 adidas presented the 'Tokio 64',
purportedly the lightest track shoe
ever made. Shod in adidas, top
sprinter Bob Hayes went on
to win two breathtaking
gold medals
in the Olympics
that year.

RECORD-BREAKING
Inexperienced 20-year-old Edwin
Moses took gold in the 400m
hurdles at the 1976 Olympics
wearing adidas. Breaking
the world record,
he won the race
by a staggering
eight metres.

THE MAGIC OF RED Clicked together three times, Dorothy's ruby slippers would transport her back home. They added a magical and enchanting touch to the film *The Wizard of Oz*.

Red shoes

1939

Judy Garland stars in MGM's classic film *The Wizard of Oz*, and her ruby slippers are to become the most famous shoes in the world. But what is it about red shoes?

In a seminal movie moment that has delighted three generations of moviegoers, the lost child Dorothy (played by 16-year-old Judy Garland) closes her eyes, taps the heels of her ruby red slippers together three times, and says, 'There's no place like home', before being whisked back to her home in Kansas from the magical land of Oz.

Red for attention

In fact, in L. Frank Baum's classic fairytale that provided the inspiration for the movie, Dorothy does not wear ruby slippers at all – they are silver. However, MGM screenwriters knew that silver wouldn't stand out on screen and decided that red would hold the audience more, so changed the shoes' colour. No-one knows exactly how many pairs of ruby slippers were originally made for the movie; Toto the dog allegedly chewed one pair on the set! But four pairs are known about today and, in May 2000, a pair were sold at Christies in England fetching a staggering £451,000, making them the most expensive pair of shoes ever sold at auction.

Regal red

Throughout history and across a variety of cultures, red shoes have had a special significance. Red heels were once worn to indicate status. In 17th-century France, King Louis XIV solved his height problem by wearing high-heeled shoes (plus his famous towering wig). Being a flamboyant king, he had his heels painted red, with the result that red high heels became a sign of nobility and could only be worn by approved members of the court. (He couldn't have everyone in the land wearing heels; the diminutive monarch would then have been back to square one!) If these individuals went out of favour but still wore the red heel as a status symbol, they were beheaded – an extreme case of fashion victim!

The colour of passion

The French weren't alone in choosing red to indicate status and wealth: from the ancient dynasties of China to the Pope's red slippers in the Vatican, red shoes have always been regarded as special. But why red? Well, originally it was a very expensive dye so you had to be wealthy to wear anything red. Symbolically, the colour red represents blood, passion and fire, but it also has powerful physical properties – red catches

EYE-CATCHING RED
These dainty red satin slip-on shoes date from the early 1800s, when red was still a very popular colour among the aristocracy.

the eye and holds the gaze more than any other colour. The bottom line? If you want to be noticed, wear red!

Red alert

For some, however, red equals the wrong kind of attention, and when paired with women has been seen as a mark of wantonness. Such is the simplified message in Hans Christian Andersen's fairytale *The Red Shoes* and in the 1948 movie, in which lead actress and dancer Moira Shearer proved that slipping on a pair of red shoes can lead to ruin. Moira played the role of Vicky, a woman torn between dancing and living a settled married life. When she chose dancing, her red ballet shoes (see opposite) took on a life of their own and – to cut to the chase – led her off the path of righteousness and into the path of a passing train. In the original story the heroine didn't die (it's a tale for children after all) but is saved from dancing to death by having her feet cut off – phew!

Fifty years later and the same connotations survive: in the 2000 film *Chocolat*, Juliette Binoche played a sensual nomadic confectioner who wore red

Christian Louboutin

High-heeled red shoes scream sex appeal, being said to exert a powerful attraction on many men. French shoe designer Christian Louboutin knew as much when he decided to make red soles for every pair of shoes he created, regardless of their colour. Further, the heels of all his shoes leave behind an imprint of what Louboutin calls 'a red rosette'. They are 'follow me' shoes, he says. When Louboutin was 13, a flash of red caught his eye. He turned to see a woman wearing red high-heeled shoes. The image stayed with him!

shoes; the message being that she is not afraid to display her sexuality... and is therefore a menace to polite society, the hussy! This intolerant attitude is best summed up by the Brits with their once-popular adage, 'red shoes, no knickers'.

But not everyone sees red when they see red. In many cultures, red is an auspicious colour associated with success, health and happiness. In China, for example, red bridal shoes are thrown on to the roof of a newlywed couple's home to ensure happiness and to make sure everyone knows that the happy couple are enjoying their honeymoon!

WHEELY NICE!
These red 'Wheel Heel' court shoes designed in 1962 are rather sexy but you can't help wondering how on earth you'd be able to walk in them!

" You shall dance in your red shoes...till your skin shrivels up and you are a skeleton.

HANS CHRISTIAN ANDERSEN

The beautiful but deadly red
ballet shoes worn by dancer
Moira Shearer in the 1939
movie *The Red Shoes*.

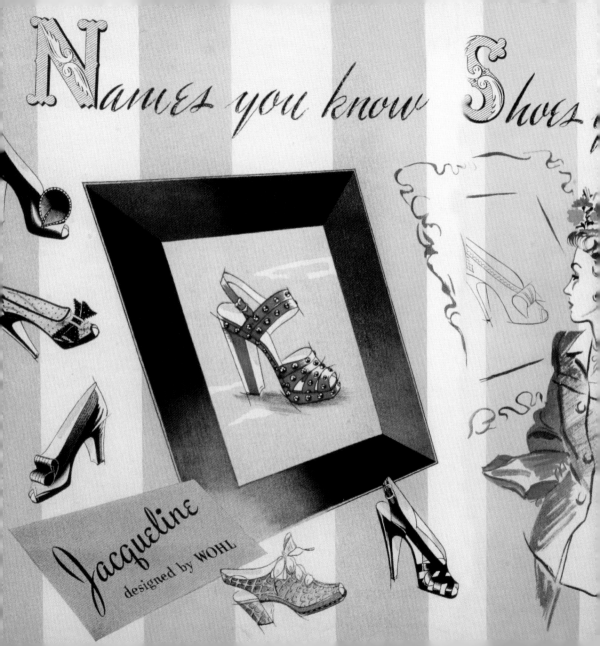

Names you know Shoes

Jacqueline
designed by WOHL

u love

Connie
SHOE CREATIONS

The Hollywood Years

The 1940s began with rationing so severe that heel heights were limited. As a result, flats grew in popularity. However, after World War II, a higher heel returned, with film actresses helping to glamorize these sexier shoes. The early 1950s saw the arrival of a much slimmer stiletto, which grew in height until pumps with four-inch heels were the apex of fashion. Fast forward to the 21st century, when we are again celebrating sexy, feminine footwear and the stiletto heel still smacks of sex and glamour.

4 *1940–1959*

Keeping up appearances

1941

In the US, each person is rationed to three pairs of shoes per year, in only six standard-issue colours, mostly neutrals, and heels must be no higher than one inch – flats were in!

Hot on the heels of the Great Depression came World War II, delivering another blow to both morale and wardrobes. Clothing, among other things, was hard to come by, since what countries could afford to manufacture had to be sent to the enlisted men fighting overseas.

they were good for the economy! Clogs, also, saved on sole leather, and were made as stylish as possible and luckily were in keeping with the 'chunky' designs that had been high fashion since the late 1930s. However, wooden heels were noisy and sometimes uncomfortable.

Making the best of it

Women were encouraged to 'keep up appearances', despite wartime restrictions. But fashion always finds a way, and style-makers responded with utilitarian chic. Magazines espoused sturdy fabrics, no-frills designs: shorter, straight skirts worn with shorter, snug jackets. People bought patterns and learned to sew. Or they reworked what was already in their closets. Where did that leave shoes? Out was anything sparkly, ostentatious, whimsical or de luxe. In were flatter shoes that did the job, but used less leather, fabric, or anything else for that matter. Women enjoyed the comfort of these flats *and*

What a corker

A popular and available option for cheap shoe material was cork, cut into wedges of an inch or two or fashioned into not-so-high platforms. Sandals using cork were a favourite since they expended the least material and lent themselves to fabric uppers. In fact, these were worn even in cooler

STYLE AND COMFORT
This black sackcloth shoe kept to the style of the time but was comfortable enough to wear all day in the factory.

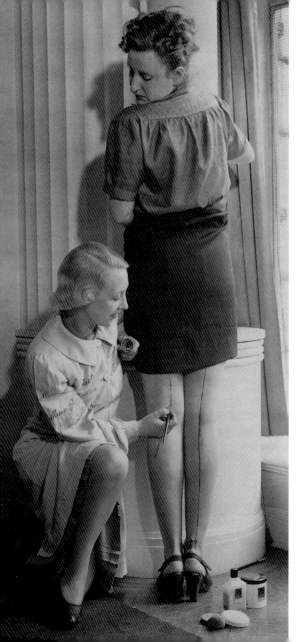

Walking the walk

As your mother might have said, there's no point in spending all that money on a posh pair of shoes if you end up walking like a duck. Finishing schools taught nice gals the social etiquette necessary to snag a good husband: how to get out of a sports car, the correct cutlery to use at the dinner table and the right way to walk. Forties pin-up stars, such as Betty Grable (right), spent most of their time in heels and soon learnt how to stand and walk in order to show off their assets. Follow in their footsteps: walk in a straight line, legs close together, with one foot slightly overlapping the other with each small step you take – easy!

weather with ankle socks (nylon stockings were no longer available). Flat-soled Oxfords and short-heeled pumps were also around, with a moderately rounded toe shape – this was not a time for extremes! Women would dress up their shoes with ornaments made from household items such as pipe cleaners, embroidery thread, flowers, old costume jewellery and whatever other pretty things they could find.

CORK SAVES THE DAY
Cork is cheap, light, comfortable and easy to work with – the perfect economical material for shoes!

NEEDS MUST!
Women compensated for a wartime shortage of nylons with an innovative use of cosmetics.

Laird, Schober

PRESENTS THE ARISTOCRAT
OF SNAKESKINS IN 1942'S
DRAMATIC HIGH COLORS,
BATIK RED, TROPIC BLUE,
PARRAKEET GREEN, JUNGLE
GOLD AND HEMP-BEIGE.

LAIRD SCHOBER shoes
8.95 to 10.95,
Snakeskins 9.95 & 10
Sold exclusively by
stores throughout the
States. If you do not have
name of your nearest
write to Laird Sc
West 34th St.

REPTILIAN SHOES IN VOGUE
The skins of snakes could be
turned into quite glamorous shoes,
as this 1942 advert shows. Even
after the calf leather shortage ended,
snakeskin shoes remained freely
available in more exclusive boutiques.

EVERYDAY SHOES
Whilst the less well-off usually had to persevere
with fabric shoes, it tended to be only more wealthy
women who could afford the newly fashionable
shoes made of exotic reptile skins. Right,
a green crocodile court shoe; above,
the innovative use of crocodile
skin as trim and above right,
snakeskin as a wedge.

Crocodile shoes

1942

The impact of World War II finds fabrics and leathers in short supply, but shoe manufacturers turn to the use of exotic animal skins to preserve calf leather for the military.

As leather continued to be scarce, shoemakers – always a creative bunch – continued experimenting with various fabrics: old-fashioned favourites such as brocade, satin, silk, canvas. But many cobblers craved the sturdy suppleness of leather and began to look around for replacements for the cow and the other mammal hides also in short supply.

New leathers found

The obvious answer, perhaps, was non-traditional skins from animals not typically used for food: reptiles and large exotic birds. Crocodile was one of the first animals whose skin became shoes; the skin's nubby texture was popular and was mixed with cloth or used alone in pumps, sandals, Oxfords, men's shoes and even handbags and luggage. Lizard-skin and snakeskin followed. Then ostrich, skins from various mammals (kangaroo from Australia, whales in Japan, for example), and even fish were fashioned into footwear.

Glamorous new wartime shoes

These shoes weren't just any 'have to make do' kind of shoes, but elegant creations that said 'glamour', despite the unfamiliar materials they were fashioned from. These days, most of us would consider the use of these skins as controversial to say the least, so how did women feel about wearing them on their feet? Well, in the 1940s, snakes, lizards and the like were not associated with luxury, and in the US especially, were identified with the homemade footware of cowhands and hillbillies. Designers such as Ferragamo, Perugia, Jourdan and Vivier glamorized these lowly skins by dyeing them in bright shades. Not only did this make the animal skins look glorious, they also made the shoes so showy that they couldn't be mistaken for 'desperation wear'.

A PLAICE IN FASHION
Designed by Roger Vivier, these colourful shoes with matching handbag, are made of fish skin – plaice, to be precise!

Shoes of the silver screen

1949

The fashion industry presents the 'King of Pumps', David Evins, with a coveted Coty Award for his décolleté shell pumps – shoes are back!

Throughout his career, Evins – aka The King of Pumps – designed classic shoes sought after by the wealthy. Born in England, in his teens, Evins emigrated to the US, where he studied fashion illustration. His sketches of shoes were so fanciful, however, that they got him fired. 'They reek of artistic license,' said the *Vogue* editor who dismissed him.

Shoemaker to the stars

Next career stop: shoe designer. While creating for master designers Bill Blass and Oscar de la Renta in the early 1930s, Evins' wares caught the eye of several Hollywood costume directors, who sought out the young man for movie work. One of Evins' earliest, most memorable commissioned pieces was a multicoloured pave wedge sandal with tubular straps that he designed for Claudette Colbert to wear in the 1934 production of *Cleopatra*. (Nearly 30 years later, Evins made an equally unforgettable pair of shoes for Elizabeth

EVINS' SHOE LADIES

RITA HAYWORTH
One of the biggest stars of Hollywood's golden age, Rita Hayworth's greatest success was in the 1946 movie *Gilda*. As the film's trailer proclaimed, 'There never was a lady like Gilda!' David Evins agreed – he designed Hayworth's shoes.

MARLENE DIETRICH
A big fan of Evins, Dietrich starred in such films as *The Lady is Willing*, *Morocco* and *Destry Rides Again*. She felt that shoes were more important than the dress or suit, giving elegance to the entire appearance.

Taylor's 1963 version of the same film: gold brocade mules with silver sequins and jet beads.) Among the other magical shoes Evins created were the glamorous black satin slingbacks with platform heels and a subtle row of rhinestones that Rita Hayworth wore in her pin-up photographs; chi-chi mules for Ava Gardner; clunky pumps for his close friend Judy Garland; and short leopard-print boots for Marlene Dietrich.

Royalty, too
During the 1940s Evins was lauded not only for his pumps, but also for his platforms. He continued to shod the stars into the 1950s: Audrey Hepburn's brocade pumps from *Sabrina*; the rhinestone 'stop and go' mules – one red and one green – worn by Ava Gardner in

GLAMOUR RETURNS
By 1949, high heels had been welcomed back into American fashion; shortages were thankfully no longer an issue.

Dancing in the Dark; and Grace Kelly's twisted pearl sandals worn in *To Catch a Thief*. Off-screen, Grace Kelly entrusted Evins to create a pair of elegant flats for her marriage to the diminutive Prince Rainier of Monaco.

Evins is also renowned for being the first shoe designer to secure halter-backed sandals with Velcro and for being the first to dye alligator skin vivid colours such as turquoise.

The 1960s saw Evins still at work, creating his highly popular mod designs: thigh-high boots, boot stockings, and pant boots to be worn with 1960s and early 1970s pantsuits.

GRACE KELLY
Kelly shot to stardom after she landed the role of Amy Kane in *High Noon*. She also starred in the Alfred Hitchcock hits *Dial M for Murder* and *Rear Window*. Evins designed the twisted pearl sandals that Kelly wore in the 1955 movie *To Catch a Thief*.

" *Sheer simplicity is my forte. It's not what you put on but what you take off.* "

DAVID EVINS

The Italian job

Since returning to his native Italy from the US in 1927, master shoe designer Salvatore Ferragamo had gone from strength to strength. By 1948 his Florence-based company began producing some of its most innovative designs at a time when the British trade magazine *Footwear* declared, 'The heavy, bulky shoe is definitely OUT.' For Ferragamo, the typical 1940s shoe was 'heavy [and] graceless...with points shaped like potatoes and heels like lead'. Now, through his expert craftsmanship and an eye for elegant, modernist designs with higher heels, Ferragamo was busily creating an enviable reputation for himself. Movie stars flocked to fashionable Italy and made a beeline for Florence to pick up a pair of Ferragamo's shoes – actress Greta Garbo bought 70 pairs of shoes in one go! The US producer and director Cecil B. De Mille also leant on Ferragamo, asking him to design the shoes for his 1956 blockbuster *The Ten Commandments*. Even more famously, screen goddess Marilyn Monroe owned 40 pairs of Ferragamo's shoes, remarking that his designs had 'given a lift' to her career. Renowned for her unusual style of walking, a former columnist on the *Los Angeles Herald Express*, Jimmy Starr, claimed to know the reason why: 'She learned a trick of cutting a quarter of an inch off one heel so that when she walked, that little fanny would wiggle.'

Queen of the platforms

The nothing if not flamboyant Carmen Miranda appeared in a number of films throughout the 1940s, each time wearing her trademark fruit-topped head wrap, cutaway skirt, midriff-bearing bolero and ever-present platforms, sandals and, less often, platform mules. The precariously towering shoes were as much a symbol of Miranda's goofy sensuality as the bananas perched on her head, but she could still dance and shimmy in them. As Miranda's movie career continued, her platforms got more extreme. Her favourites featured bright colours – even prints! – with heels upwards of seven inches and toe platforms two to four inches high. Hollywood designer Salvatore Ferragamo produced most of the diva's footwear, often adding something extra to the shoes, such as rhinestone-embellished heels or nail-studding.

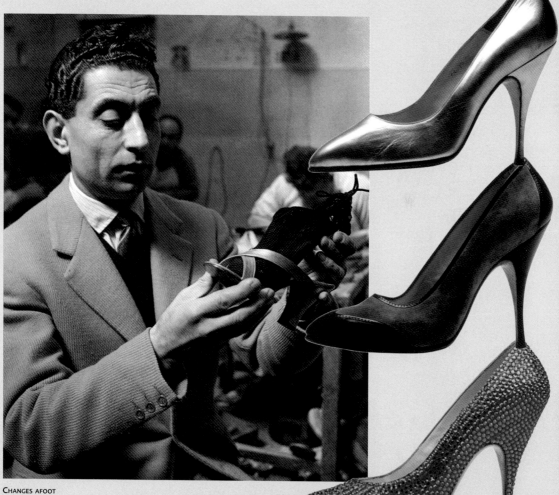

CHANGES AFOOT

Between 1927 and 1960 (the year of his death), Salvatore Ferragamo produced 20,000 shoe designs. Until the late 1940s, utility shoes, encapsulated in his own wedge-heel styles (see page 48), had more than made their mark and the designer himself conceded changes were afoot. Ferragamo promptly added heels to his shoes.

Arrival of the stiletto

1951

French shoe designer Charles Jourdan decides to try something different with the era's *de rigueur* pumps. He slims down the heel to create one of the sexiest, most sensuous shoes ever made.

After years of rationing, post-war women were more than ready to start shopping. Gone was cautious penny-pinching (in the US at any rate; Britain slowly caught up, having been more badly affected by the war). Now women window-shopped. They met their friends for 'luncheon' at department stores and visited shoe shops – suddenly it was important to have the modern look, and in shoes, it was the Jourdan-style new heel. Jordan felt compelled to christen his new barely-there design the stiletto, named after a small dagger with a tapered blade, which the heel resembled.

FROM HOUSEWIFE TO GODDESS 'Notice me!' was the message from stiletto-wearing women. Now taller and sexier, ladies were upping the style stakes.

High times, high heels

These razor-thin heels soon caught on, and the nascent stiletto became *the* look for the early 1950s. Not much else in the shoe's design changed, though. The toe was still a neutral shape: not too round, not too pointy, definitely not square. The vamps were most commonly V-shaped, and the material could be a sumptuous cloth or beautifully soft leather.

The most obvious transformation in the creation of the stiletto lay in the increased angle between the wearer's heel and the ground. Today we are accustomed to seeing stilettos with heels of five or even six inches, but Jourdan's originals were of a slightly more manageable height, mostly two or three inches. This was the era of the innocent stiletto – no tarty, staggering, bondage heels here!

It is testament to Jourdan's classic design that the stiletto heel has remained relatively unchanged in over half a century. The ultimate in high heels is still very much in the ascendant.

THE HEEL'S THE DEAL
When did a couple of inches ever matter more? Higher heels meant longer legs, greater sex appeal and an unequivocal sense of power.

Charles Jourdan

After his stiletto success, Jourdan decided to create a recognizable 'luxury-associated' shoe label. He named the line after himself and opened a boutique in Paris in 1957. Wow! Women mobbed the store, prompting Jourdan to institute assigned numbers and strictly enforced customer queues. Stars such as Brigitte Bardot were forced to enter and leave through the store's service entrance! Fashion designer Christian Dior was curious enough to visit. He liked what he saw – the shoes were exquisite in craftsmanship, sleek in silhouette, with an elegant, aristocratic look. He promptly granted Jourdan a license to design and manufacture Dior shoes. The result was Jourdan's entrance into the world of haute couture.

WALK THIS WAY...
A 1950s ad for heeled shoes of differing heights, but it's the tallest, sleekest, sexiest stiletto that takes centre stage.

Patent Leather

Paradise shoes

By royal appointment

1953

Queen Elizabeth II is crowned at a coronation ceremony in Westminster Abbey in London. Adorning the royal feet are the creations of French shoemaker extraordinaire Roger Vivier.

The Queen wore an opulent white satin dress commissioned from royal courtier Norman Hartnell. The dress's exquisite embroidery in gold and silver thread and pastel-coloured silks was encrusted with seed pearls and crystals to create a lattice-work effect. And the shoes? Gold, curving strands of kidskin leather (to match the gown's shimmering embroidery), offset with garnet-encrusted heels. In a word: magnificent.

Royal trendsetter

The only downside to the big day was that poor Elizabeth visibly minced her steps whilst wearing her fantastic footwear, the custom-designed creation of French shoemaker Roger Vivier. But comfort be damned – the things were gorgeous enough to ignite a trend among fashion-forward types for fanciful, formal shoes with decorated heels. Hollywood lovelies such as Marlene Dietrich and Ava Gardner were soon seen wearing similarly whimsical creations, and the newly crowned Queen would later wear other types of light-hearted pumps.

Born in Paris in 1907, Roger Vivier studied sculpture at the École des Beaux-Arts before taking a sideways step into shoe design. This dual education offers a telling explanation as to why Vivier described his shoes as wearable sculptures. Others called them 'works of art' and the 'Fabergé of

footwear', while the man himself was referred to as the 'Fragonard of shoes' – a reference to the 18th-century French painter, whose work embodied the frivolity and excess of European high society at that time.

The coming of the comma heel

Before striking out on his own, Vivier worked from 1953 to 1963 for Christian Dior, where he created footwear that complemented Dior's hyper-feminine, body-restrictive

LUXURIOUS EMBELLISHMENTS
Christian Dior was the leading fashion designer of the 1950s. These exquisite blue–grey satin court shoes, with stiletto heel and bow trim on the vamp, help explain his popularity.

> "*To wear dreams on one's feet is to begin to give reality to one's dreams.*"
>
> ROGER VIVIER

fashion. Vivier spent his time at Dior wisely, experimenting with all means of shoe materials, such as silk, pearl and bead embellishments, lace, glass, and jewels, both real and fake. He also played with heels, creating his signature 'comma heel', and was one of the designers who developed a taller stiletto, still very much in vogue today.

Take me higher

Rumour has it that Vivier enlisted the help of Italian engineers to understand the physics involved in keeping a woman's body propped up on this lofty twig of a heel. The answer: a thin, metal insert, encased in plastic, hidden in the heel's core. Et voilà! Four-inch spike heels, here we come! Interestingly, Vivier's main rival at the time, Salvatore Ferragamo, was also credited with the same accomplishment, also using Italian engineers. Yes, it looks as if this was one of those simultaneous fashion moments.

FIT FOR A QUEEN
No matter what the occasion, the Queen always has to wear shoes that are not only practical (we can't have her doing a Naomi Campbell-style tumble), but they also have to be elegant and perfectly matched to the outfit in question – in this case, a white embroidered lace gown with blue satin robe, worn in 1968 for an anniversary service at St Paul's Cathedral, London.

A new kid on the block

Edward Rayne, another favourite shoe designer of the royal women, was born in London in 1922 into a family of shoe-makers who made their livings creating shoes for actresses. By the time of Rayne's birth, the family business had branched out to London's Bond Street, where it became a fashion favourite. Joining H&M Rayne in 1940, Edward sought out the already well-established Roger Vivier, who fostered the rookie cobbler's love of fancy heels and

sophisticated designs. Encrusted heels – beads, pearls, gems and cut glass – were especially dear to Rayne. Young Edward soon prospered, and the high quality of his shoes, coupled with their almost-on-the-edge elegance, made him a favourite of the younger royals. He was granted a Royal

Warrant, and in 1947 was asked to design Princess Elizabeth's wedding shoes – ivory silk numbers embroidered with seed pearls and dressed up with a moderate heel.

H&M Rayne emerged as an international force in shoemaking. Throughout the 1930s, 1940s and 1950s, the company boasted the Queen Mother among its clients. In addition to keeping Her Majesty supplied with her favourite white calf or suede shoes, the company even created foot-wear for her featuring five-inch heels and platform soles, although they were probably never seen in public!

ALL IN WHITE
The Queen Mother's proclivity for white shoes with a heel wasn't missed by designers, who were always quick to exploit the mass influence of the royals.

DIAMANTÉ FOREVER
The days of painstaking precision that must have gone into these women's embroidered, gold-net evening mules with encrusted stiletto heel was time well spent. They were designed and made by Edward Rayne between 1953 and 1959.

Blue suede shoes

1955

Bill Haley's huge hit *Rock Around the Clock* heralds the arrival of rock 'n' roll from America. This exciting new music style is soon influencing how young fans dress all over the world.

In Britain, young men donning huge quiffs, tight, narrow trousers, long jackets and suede Oxfords become fondly known as Teddy boys. Their unique look epitomized the 1950s.

The Teds

Their attitude? Some looked to American pop culture, developing a fascination with gangsterism (petty crime, defiance, knife and razor fights, smart suits); others just loved the rock'n' roll side (the music, the dancing, the cars and motorcycles, the attitude). Their hairdos? Think Tony Curtis, James Dean, Bill Haley, Carl Perkins, Buddy Holly, Jerry Lee Lewis, Elvis and any other of the young Americans becoming part of British consciousness. In other words, a greased-back quiff – called a pompadour in the US – combed into a DA (short for, er, duck's arse).

The shoes

The shoes have become absolute classics. First there was the crepe-soled, suede, lace-up Gibson Oxford, which was quickly joined by the more extreme high-rise brothel creepers, footwear that sported a two- or three-inch slap of crepe under a suede Oxford. Suede shoes were readily available, especially in neutral shades: brown, tan, russet, black, even off-white. Coloured suede was more unusual, making it highly prized. Hence the allure of blue suede shoes as so rare, so special that a man felt the need to warn his lover not to step on them!

DANCING IN THE STREET!
Bobby socks worn with flat shoes for jiving were all the rage in the 1950s.

SPRING-O-LATOR SHOE
Designed to improve the comfort and fit of a shoe, the wedge-shaped Spring-o-lator ensured that any creation would stay on while you danced.

" Dream as if you'll live forever. Live as if you'll die today."

JAMES DEAN, THE ULTIMATE MID-1950S' YOUTH

Teddy girls (also known as 'molls') wore the raciest stilettos available. All the better to draw attention on the dance floor, while leaning on a teddy boy's car, or swinging one's leg in a carefree way trolling for attention. Completing the look was heavy eye make-up, ponytails and either full, American-style circle skirts or drainpipe pants. Oh, to be young and trendy!

As for fashion, other girls wore full knee-length skirts over layers of net petticoats, with socks and flat shoes. Pumps were out (those were for old ladies!), so saddle shoes and penny loafers were chosen, flatter shoes being ideal for dancing, which was what the 1950s were all about: athletic dances with dips, twirls, fancy footwork, so flat, rubber soles were definitely necessary!

JEEPERS CREEPERS!
Brothel creepers allowed men to sneak around at night without a sound – useful, huh?

THE COOLEST FIFTIES SHOE?
The severely pointed winkle-picker – a slip-on or laced buckled loafer – made its way into the male wardrobe in the late 1950s, gradually taking over from the brothel creeper.

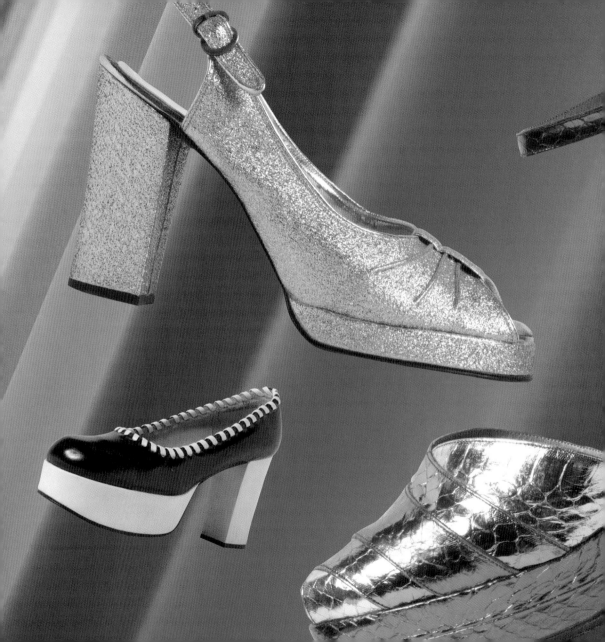

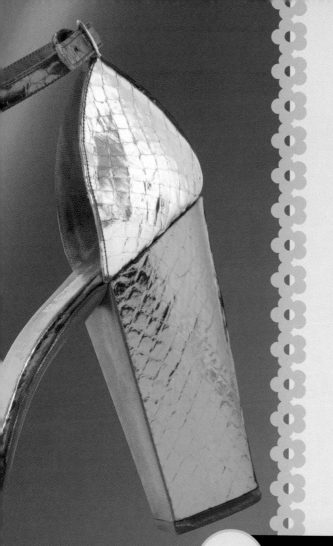

The Pop Years

In the early 1960s, women began ditching their stilettos for the low, chunky heels favoured by style icons such as Jackie Kennedy and Audrey Hepburn. They were soon accompanied by go-go boots, mod fashions and other swinging Sixties styles, but it wasn't until the early 1970s that eye-popping platform shoes appeared on glam rockers and dancers everywhere. Shoes soon turned into an art form, with exhibitions displaying the most unwearable shoes ever seen. It seemed whatever your taste in footwear, there was a shoe out there with your name on it.

5 *1960–1979*

1962

The Jackie influence

While millions of fans mourn the loss of beautiful movie icon Marilyn Monroe, President Kennedy's glamorous wife, Jackie, dazzles the world with her elegant looks and style.

In terms of dress, music and social mores, the early 1960s more closely resembled the 1950s than the wilder, late 1960s, and the undeniable Fifties-style femininity of stars Janet Leigh, Audrey Hepburn, Elizabeth Taylor and Doris Day still ruled Hollywood.

Heels go down

Fashion's silhouette started to shift ever-so-slightly. Skirts became less full and a tad shorter. Garterless panty-hose and tights were created, paving the way for the shorter hemlines. The stiletto heels of the late 1950s were joined by shorter kitten heels: sexy, delicate and easier to manoeuvre in than dagger-like heels! Toe shapes changed, too. By 1961, pointy toes had been squared at the very end, and by 1963, the toe was slightly rounded; again, just at the end.

Jackie's style

One of the biggest things to happen to fashion in the early 1960s was Jacqueline Bouvier, the young wife of the US president, John F. Kennedy. Probably the US's most style-conscious first lady, Jackie set trends just by being herself. Her clothes were sleeker than the full skirts and nipped waists prevalent at the time, and her hair was less fussy, her shoes more comfortable and lower in height. Women studied Jackie's look and copied it. Soon, fashion designers began adopting Jackie's silhouette – she was the epitome of chic.

One of the most interesting things about Jackie's wardrobe was her shoes. Rejecting the high skinny heels of the time, she knew that lower-heeled silhouettes would pull her gently tailored outfits together in a more complete way than the day's popular stilettos. She owned dozens of short-heeled pumps in an array of cloth and leather, colours and toe shapes. Some of these were Chanel pumps with the contrasting-coloured toe, others were bespoke Italian shoes that were created by a local shoemaker on Jackie's many trips to Italy. She also loved ballet-style flats, moccasin-style loafers and high riding boots. But whatever she wore, she looked perfect.

CLASSIC ELEGANCE
Audrey Hepburn was style and femininity personified – flat loafers never looked so good!

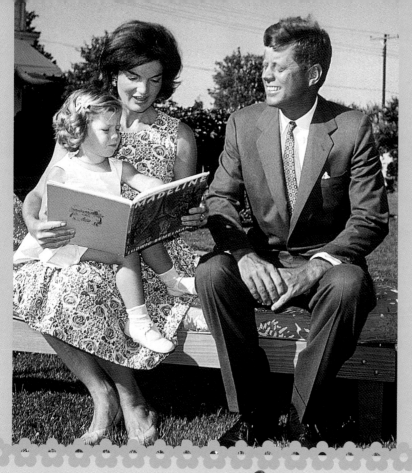

"It looks like it's been furnished by discount stores."

JACQUELINE KENNEDY,
DESCRIBING THE WHITE HOUSE
WHEN SHE AND JOHN FIRST
MOVED IN, IN 1961

A BREATH OF FRESH AIR
First Lady Jackie Kennedy, here with daughter Caroline, spent a fortune on her wardrobe, but she brought a beauty, style and glamour to the White House that had never been seen before.

SIXTIES SHOE ELEGANCE
These gorgeous creations were typical of what every fashionable woman was wearing in the early 1960s. From left: slingback stiletto-heeled shoes with a floral-embroidered vamp; canvas orange fabric slingback with bow on vamp; and white raffia court shoe with navy blue trim.

These boots are made for walkin'

1966

Boots are big, as confirmed by Nancy Sinatra's huge hit *These Boots are Made for Walkin'*, and are usually worn with the iconic fashion item of the decade, the mini skirt.

By the mid-1960s, knee-high boots had become all the rage. When worn with the mini skirt, they were downright sexy. But any length boot was a goer, with the heels wider and coming down in height from the heady days of the 1950s stilettos.

Go-go boots

Very hip and fashionable were go-go boots (likely to have been named after the popular dance of the time). These white leather, just-below-the-knee affairs actually started off much shorter – a few inches above the ankle. French designer Andres Courrèges had created these low-heeled, white plastic boots in 1964, but by 1966, the boots had crept up the calf. Courrèges designed his white 'kid boots' to go with his white mini dresses and trouser suits. Other designers, seeing a trend, created their own versions, some taking the boots as high as over-the-knee.

Mary Quant

But it was the ground-breaking British designer Mary Quant who is most associated with the 'hip and happening' new look of the mid-1960s. There were the mini skirts, mini swing frocks, plastic raincoats, skinny rib sweaters and patterned tights that Quant sold in her London boutiques; along with the cosmetic collection and shoes she debuted in 1966. Plastic and plastic-look materials were favourites, and it wasn't uncommon to find a boot made of a clear plastic set directly over a boldly coloured jersey, giving the shoe a textured look with a high-shine finish. As higher boots became more popular in 1966, Quant offered these, too, most often in trendy white kid or patent leather. Fab.

PARTNER OF THE MINI
These black and white plastic boots are unmistakably 1960s style.

BEST FOOT FORWARD
Mary Quant (front) shows off her boot collection in 1967. The boots came in all shapes and sizes, but the plastic ankle boot (left) was the favourite.

" Fashion, as we knew it, is over; people wear now exactly what they feel like wearing. "

MARY QUANT

STAR-SPANGLED
With all eyes turned to the sky, the 1960s space programme was reflected in the decade's fashion trends, leading women's shoes to shine like never before.

WALKING ON AIR
Although the clothes at the time were mainly shiny and plastic, space-age fashion didn't have to mean tacky, as this elegant silver Charles Jourdan shoe shows.

SPACED OUT
Silver was the new black and shoes became much more futuristic, created in far-out fabrics, such as vinyl, PVC and polyester.

Space-age fashion

1967

With the space race going strong, and a moon landing only two years away, galactic fashions begin to rocket. Alongside smocks and kaftans are catsuits, body stockings and sparkly boots.

This was the year of the spaceship – a record number 157 spacecraft were launched, mostly by the US and USSR. Back on earth, hippies gathered at the first 'Human Be-In', the Summer of Love and the Monterey Pop Festival, all held in Northern California but with a worldwide audience.

Groovy, baby

With the Apollo moon programme catching the public imagination, Pierre Cardin introduced his extraterrestrial collection in 1967 with futuristic catsuits and body stockings. Andre Courrèges, who had pioneered the lunar look in 1964, was still at it three years later, with a fresh crop of silver PVC 'moongirl' trousers, white catsuits and monochrome striped mini skirts and dresses – all in silver and white PVC with bonded seams.

As you'd probably expect, these far-out fashions influenced shoe design. Boots are de rigueur: short 'pant boots' for the catsuits, mid-calf to over-the-knee boots for the minis. But what was really amazing about 1967 was the materials used to make these boots. Stretchy, shiny, sparkly vinyl blends, polyesters and close-fitting fabrics show up in almost every shoe designer's collection, and the most popular boots are clingy, sock-like affairs, either short, or as high as the thigh.

Cutting edge shoes

In 1967, a former shoe model won the prestigious Coty fashion award for a pair of stretch boots. A perfect size 4B, Beth Levine was obsessed with construction and comfort. Not, of course, at the expense of style! Beth Levine's shoes were fanciful, cutting edge, strange and shocking, and many of America's biggest celebrities visited Levine's studio: Barbra Streisand, Liza Minnelli, socialite Babe Paley, and US first ladies as different in personality as Jacqueline Bouvier Kennedy and Pat Nixon.

Meanwhile, the hippie movement was in full flow. The coolest footwear was…none. But going shoeless wasn't always practical, of course; sandals, moccasins and suede-fringed boots were the most popular choices of hippies.

WALKING ON THE MOON
The influence of the Apollo programme can be seen here, with these white leather boots, reminiscent of an astronaut's footwear.

Heels reach new heights

1972

Glam rockers storm the music scene, trussing themselves into huge padded shoulders and glitzy six-inch-high platform boots, stretching the fashion conventions of their time to the limit.

Platform shoes had first appeared on the scene centuries before, but they reached their apex in the early 1970s. Ridiculous? Impractical? Maybe, but the platform shoe epitomizes the 1970s (a decade which many think style forgot!). The higher the platform, the better. The clunkier the better. And certainly, the gaudier the better. The platforms started off with a slim sole of about one-quarter of an inch, but crept higher until soles of two inches were quite common. As were accidents involving twisted ankles! Not all were into 'glam' fashion, yet the over-the-top platform filtered down to the high street.

STANDING TALL
This dazzling pair of platform boots were typical of the sort worn by the glam rockers of the early 1970s.

Glam rock

Platforms were an important part of a peculiar sub-genre of early 1970s rock: glam rock, a musical movement less about a particular sound than flamboyantly clad musicians stomping around stage in glitzy platforms of dizzying heights. The mascot for the movement was chart-topper Gary Glitter, born Paul Gadd, in England. His greatest hit was probably *Rock 'n' Roll*, released in late 1972 and played at American football games

ABBA
This legendary Swedish group went on to achieve huge success all over the world, and their outfits are fondly remembered.

PLATFORM GALLERY

SENSIBLE SOLE
Even the most sensible of 1970s shoes weren't complete without a sturdy platform sole and heel.

OFFICE CHIC
Stylish platform court shoes meant secretaries were soon towering over their bosses.

PRETTY IN PINK
The feminine touch could turn gaudy glam rock platforms into the height of girly fashion.

LAZY DAYS
Platforms didn't have to be glamorous, however. These raffia sandals were perfect for the beach.

everywhere. Not to be overshadowed by his music was his wardrobe: over 30 silver glitter suits and 50 pairs of extreme platform boots, which helped to launch the glittery, outrageous, glam fashion adopted by other popular musicians of the time such as David Bowie, Marc Bolan, Slade and Elton John.

Kiss

Formed in January 1973 was the American group Kiss – rock-focused, rude, loud, and the rumoured inspiration for the fictional classic movie *Spinal Tap*. In addition to character face make-up, superhero-style leotards and enormous coifs, the gang of four wore platforms. Usually silver, sometimes black or red or a combination thereof, and always high enough to be dangerous.

" We looked like bad drag queens. "

GENE SIMMONS, ON KISS'S IMAGE

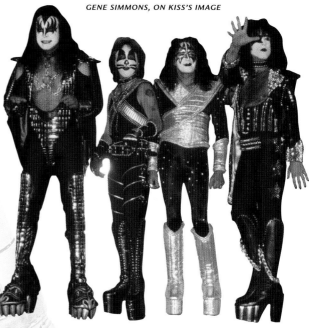

NOT ONE TO TAKE HOME TO YOUR MOTHER
Kiss was the acceptable face (albeit heavily made up), of glam rock in the US.

NOT FOR THE OFFICE
These metallic red, silver and blue mock crocodile platform sandals were made in 1972, at the height of the glam rock period.

Dizzy heights

Too scared to wear high heels? Try a low, chunky heel first before graduating to the higher, skinner stiletto. Charles Jourdan's 1970's 'Madly' shoe (below) would have been ideal. Slip them on and walk, keeping your legs straight and close together and placing your heel down first and then the rest of the foot down quickly and smoothly. Try a twirl, stand on your tip-toes and do a jig (preferably all indoors, or you may get some funny looks). Practise walking on different surfaces but try to avoid ice, mud, sand and gravel (if in doubt get your date to carry you). Nothing is unsexier than taking a tumble down the stairs in your stilettos, so step slowly and grasp the handrail. Finally, as you walk, swing your arms for balance. Oh, you sexy thing!

Not just for men

As you've probably gathered, the over-the-top nature of glam rock was led by the boys. Satin and velvet outfits were mixed with sequins, feather boas, and plenty of eyeliner and glitter eyeshadow! Initially, the pop stars' appeal depended as much on their image as their music, but the likes of Elton John and David Bowie have proved that you don't need outrageous outfits and shoes to sell records.

Platform shoes themselves were very much a dual-gender phenomenon. On college campuses, at dances and social events throughout the Western world, as well as on the high street, both women and men wore platforms. Often, there was little difference in what a girl and the guy next to her were wearing.

Even in the gender-bending 1970s, however, men did refrain from wearing platform sandals. And not many ventured out in platform clogs. Oxfords were a popular male choice, dressed in the same stripes, swirls and eye-popping colours as the female versions. Boots were especially trendy with the masculine set; perhaps not as sparkly or high in the calf as those worn by glitter rockers, but funky and attention-grabbing nonetheless.

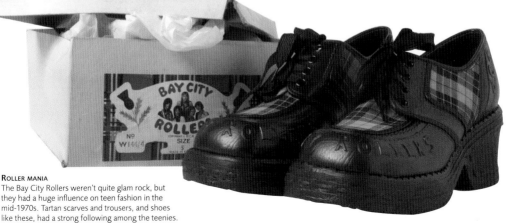

ROLLER MANIA
The Bay City Rollers weren't quite glam rock, but they had a huge influence on teen fashion in the mid-1970s. Tartan scarves and trousers, and shoes like these, had a strong following among the teenies.

Doc Martens

1976

The punk scene explodes across the UK. With their anti-establishment standpoint, shocking appearance and penchant for fast, abrasive, loud music, punks divide the nation.

Against a backdrop of economic depression and crippling unemployment, the future looked bleak in 1976. The punk movement reflected this: legions of skint, bored and disillusioned youths listened to angry-sounding bands such as the Sex Pistols, Buzzcocks and the Clash. They spiked their hair, dyed it all colours of the rainbow and wore ripped clothes held together with safety pins. Yet, bizarrely, the most essential item of this snarling sub-culture was the Dr. Martens boot – a sturdy, dependable, comfortable no-nonsense working-man's boot.

From workwear to streetwear

The eight-eyelet 1460 was punk's favoured model of 'Doc Martens', as the boots came to be known. The 1460 took its name from the day, month and year of its birth – 1 April 1960. Its famous yellow stitching, two-tone grooved sole and signature footprint made it a classic. As well as being hard-wearing, it was also economical; in the inflation-hit Britain of 1976, a pair of Dr. Martens retailed for under £20. The shoe didn't have things all its own way, however. Other styles of punk footwear included the slingback, the army combat boot, the brothel creeper, the monkey boot, and even plastic jelly sandals and white stilettos.

DESIGNER DOCS

FLOWER POWER
Inspired by Dr. Martens' spirit of originality, dozens of designers created their own version of the classic 1460; here Basia Zarzycka, designer for the elite, adds some feminine sparkle.

RIVETING
Like Dr. Martens, Levi's were originally designed for the working-man, meaning nothing looked better with a pair of Docs than some ripped Levi jeans, a match celebrated here in the extreme.

Foot soldiers

Dr. Martens will go down in history for being a paradox. Although they were a blue-collar creation, they brought people together from all walks of life... only for them to clash. Racist skinheads fought running battles with anti-Nazi campaigners, separated in the middle by the police; all dressed entirely differently except for their choice of footwear – Dr. Martens. Ironically, as the 1970s came to an end, the climax to the feuds of these warring factions and the petering out of the punk philosophy lay in a most unlikely and surprisingly upbeat source – disco!

A design for life

Dr. Martens boots were as famous for their uniform appearance as their bouncing soles. Apart from a choice of number of eyelets – ranging from 6 to 20 – and two colours – black or cherry-red – the boot was originally of a standard model. It wasn't until its producers noticed that Dr. Martens wearers were customizing their boots with unique designs that the scope for alteration and progression became apparent. Hand-painted flames, flowers and Union Jacks were particular favourites. Today, in a nod to this type of innovation, Doc Martens produces not only boots but also shoes, sandals and trainers – in any colour you can think of.

GOODY TWO-SHOES
Dr. Martens were a seemingly strange addition to the punk fashion, but the bulky, no-nonsense boots matched the kick-ass attitude of the day.

LOVELY LULU
Mimicking one of her own creations, shoe designer Lulu Guinness adds a touch of humour and femininity by turning the boots into a Parisian house.

KINKY BOOTS
Simple yet stylish, Olivia Morris takes the original 1460 to a whole new level, adding an open toe and a high heel to the classic design while retaining the colour and character.

Saturday Night Fever

1977

The smooth moves of white-suited John Travolta dancing to the Bee Gees in *Saturday Night Fever* take the world by storm, sending young people into discotheques all over the world.

In many respects, the mid-1970s were a struggle: oil embargoes, rising energy costs, high inflation, the proliferation of nuclear weapons and high unemployment rates. To escape their troubles, many young people headed for the increasingly popular disco, which influenced footwear until 1980.

Disco fever

Disco had actually started catching on in 1975, but the shoes – along with the rest of the outfit – boogied off the dance floor and into closets everywhere with the release of *Saturday Night Fever*, a coming-of-age tale set in New York's discos. Shoes worn to the disco were a glamorized version of what was already popular –

platforms: high-heeled Oxfords for him; tall, glitzy evening sandals for her. Soon, people in suburbia and rural areas were able to enjoy the sexy, body-conscious fashions seen in the film, and the shoes – again, along with the rest of the outfit – became popular evening wear for people from all walks of life.

Hardcore 70s shoe fashion

Wanting to differentiate themselves from dance floor newcomers, hardcore disco-goers donned more shocking outfits such as satin hotpants, often with matching bomber jackets, knee-high platform boots, and occasionally, roller skates,

ESSENTIAL DISCO FOOTWEAR
The sandals that no self-respecting disco gal would be without: gold textile peep-toed slingbacks.

STRIKE A POSE
The movie *Saturday Night Fever* made John Travolta a superstar, and this pose became legendary!

sparking the craze for roller disco. Popular TV characters *Wonderwoman* and *Charlie's Angels* dressed in platform boots, shoes and other discofied garb, broadening the fashion's fan base.

The dissenting shoe

For those who abhorred this look, it was not all platforms, dance sandals and silver boots. Comfortable footwear was popular, too, and perhaps no 'practical' shoe got as much attention as the Earth Shoe sandal or clog. Another feel-good favourite was the desert boot, a short boot-Oxford hybrid with a rubber-crepe sole and brushed suede upper.

Looking the part

A flamboyant type of couples dance – part ballroom, part flamenco, part jazz dance, part sex on the dance floor – was all the rage and needed clothes just as showy: the wide-lapel suit for him, an open-necked shirt with a gold medallion clearly on show. For her, a polyester wrap dress with a pair of high platform sandals such as this black suede number with a feature red rosette.

> " *What you doin' on your back? Aah. You should be dancing. Yeah.* "

LYRICS FROM 'YOU SHOULD BE DANCING' BY THE BEE GEES

DANCING ON A SATURDAY NIGHT
The epitome of glamorous 1970s disco style: the absolutely essential platform sandals, satin hotpants, glittery top and the very popular Afro hairstyle (these were the days before hair straighteners).

Shoes as art

1979

Thanks to a series of high-profile exhibitions culminating in this year's London Shoe Show, shoes are officially recognized as art. And not before time, some shoe-a-holics might say!

Smart women have always known that shoes are a serious business, but by the late 1970s shoes were sculptures, shoes were in paintings, and the explosion of exhibitions and museums around this time devoted entirely to fashion footwear meant that shoes could now be seen as bone fide works of art. Hey, what better excuse to buy a new pair?

Andy's dandy designs

As with most pop cultural crazes of the period, Andy Warhol was part of the reason the

humble shoe was elevated to the status of *objet d'art*. And, since he started his career as a commercial artist for the I. Miller shoe company designing their adverts and billboards, shoes were part of the reason for Warhol's eventual worldwide success. 'I decided that being a shoe salesman was a really sexy job,' he later explained.

Indeed, so successful were his colourful, playful shoe designs that by the mid-1950s, he was earning as much as $100,000 a year. This considerable salary enabled him to hire assistants to help produce his prolific output, a prelude to his later Factory days, when several different artists would work on each of his screen prints. By the 1970s, Warhol's shoe designs were no longer seen as mere adverts, rather as genuine works of art, and a collection of 40 of his drawings, prints and watercolours was assembled into a book, the aptly entitled *Shoes, Shoes, Shoes*.

> *" You can judge so much about a person by what they've chosen to put on their feet. "*
>
> **GAZA BOWEN**

A SPRING IN YOUR STEP

It's a shame this boot was created for the 1979 Shoe Show and was never meant to be worn, as it would add an explosion of colour to any outfit!

Gaza's sculptures

Gaza Bowen embraced the shoe-as-statement-on-society concept and became a 'shoe artist'. Hugely creative in the 1970s, the Santa Cruz-based designer made shoes – proper shoes, albeit ones with crazy names like 'Lightening Strikes Twice' and 'Wedge-A-Matics'.

Towards the end of the decade, Bowen had transferred her shoemaking skills to sculpture with shoes as her central theme and began satirizing American society via shoes. 'Shoes for the Little Women', for instance, is a shoe sculpture that incorporates domestic paraphernalia such as dishcloths and loo brushes, and 'In God We Trust' is a pair of brogues made entirely from shredded bank notes.

Flipping fabulous!

Seventies shoes could be described as many things but never boring! Even the lowly flip-flop was transformed into a high-end work of art. For years, the flip-flop was relegated to shops in seaside towns. By the 1970s, though, it was getting poshed up, decorated by beads, sequins, you name it – and for the very brave, there was the Carmen Miranda-style Fruit Flops (right). Today, the flip-flop has gone full-circle: actress Sarah Michelle Gellar wore white Havaianas to her 2002 wedding, and in 2003, when US design team Sigerson Morrison created a flip-flop with a cute kitten heel, the initial 300 pairs sold out of their New York store in under three hours, leaving women bereft of the prized flip-flops sobbing uncontrollably in the aisles.

THE GREAT GAZA
Shoe designer and sculptor Gaza Bowen has produced a plethora of politically inspired creations, such as these 'Shoes for the Little Women', a comment on the issues of feminism and sexuality. Note the pink loo brushes on the front of the shoes.

Craft Museum in New York exhibited her work in 1978, and her shoes are now part of their permanent collection as well as those at the Victoria & Albert Museum in London and the Los Angeles County Museum of Art.

The shock of the shoe

Thea Cadabra, on the other hand, turned actual, wearable shoes into artistic creations. After learning her trade from a Turkish cobbler in London, Thea set up her own studio in 1976. Her bold designs were an instant hit. In 1979 her name became synonymous with whacky, vertiginous heels when The Crafts Council staged a massive exhibition,

ENTER THE DRAGON
These colourful Dragon Shoes, another imaginative offering from Thea Cadabra, are more fancy dress than celebrity bash, although they're guaranteed to set any dance floor on fire.

'The Shoe Show: British Shoes since 1790', in London. This was arguably the first shoe-centric exhibition of its kind, and displayed everything from Lancashire clogs to 'catwalk shoes' – totally unsuitable for everyday wear!

Her creations caused something of a stir, in particular 'Cloud and Rainbow' (see right), a pair of sky-blue high heels covered in a profusion of meteorological images, and 'Maid's Shoes', fetishistic heels that incorporate a white bow and white toe front mimicking a maid's saucy apron (see page 13). Both designs summed up Cadabra's interest in the symbolism of shoes. Thea later infused her eyebrow-raising ideas into Charles Jourdan's designs, seamlessly combining the commercial and the artistic.

KICKING UP A STORM
Rain or shine, you wouldn't want to wear this beauty out in any weather.

NAKED AMBITION
Raunchy Rodolfo Ayaro designed this cheeky pair for the 1979 Shoe Show.

A museum for mules, stilettos and trainers

The natural progression from shoe exhibitions? Why, shoe museums! The UK's Northampton Museum and Art Gallery began collecting shoes in 1868 and now has two shoe galleries that look at the history of shoes and shoemaking. The museum's 12,000-shoe collection is of national importance and includes a pair of stacked platforms worn by Elton John in the 1975 film *Tommy*. Across the pond, Toronto's Bata Shoe Museum has more than 10,000 shoes, and spans over 4,500 years of history. Other museums are more singular in their vision: Museo Salvatore Ferragamo, for instance, located above the designer's flag-ship store in Florence, is devoted to the Italian maestro's designs. This all goes to show that art and shoes are inextricably entwined!

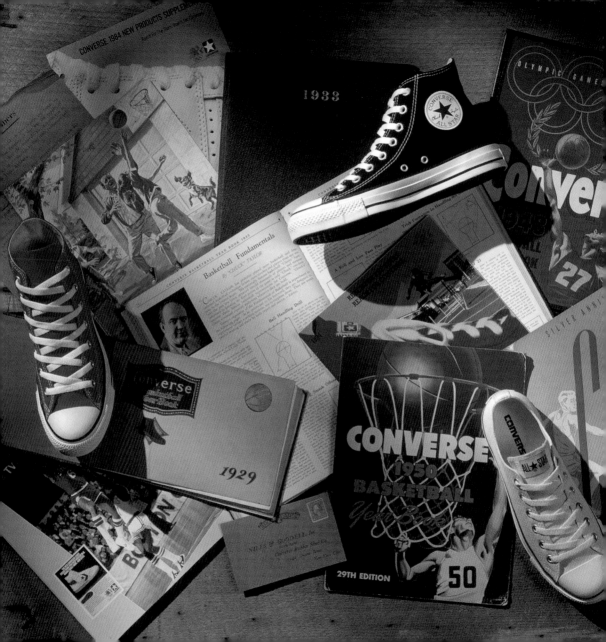

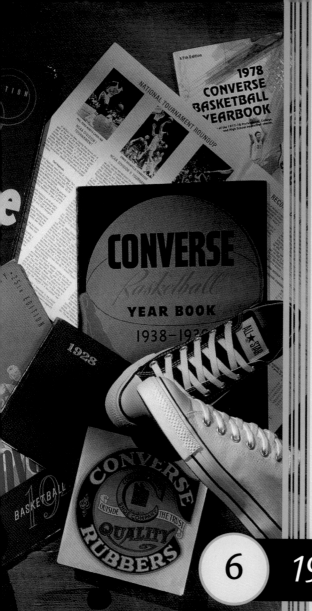

The Designer Years

Nike and adidas trainers were in, and Dr. Martens became hip (especially if they were customized). Grunge bands brought back Converse Chuck Taylors and platforms reappeared. It was all about the label, and designer names stopped being the preserve of the elite. Yet again shoes became *the* sign of status and style. Thanks to a visible contingent of fashionistas and *Sex and the City*, women yearned to own a pair of Jimmy Choos or Manolo Blahniks, although many had to settle for the flood of high-street imitations.

6 *1980–1999*

The best of British

1982

Red or Dead appears on the UK's fashion landscape, its shoes quickly growing to mythical proportions, thanks to its 'keep it real' philosophy and street-smart vibe.

The history of Red or Dead goes something like this: in 1982 Wayne and Gerardine Hemingway haul half of their wardrobe to a stall at London's Camden Market. They are hoping to raise money to fund Wayne's band. 'It was £6 rent for the stall and we took £80 the first day. It just took off from there,' recalls Wayne. By the end of the year they had 16 stalls, with shipments of second-hand clothing and footwear being bought in from all over the world.

In addition to this, they began customizing old Dr. Martens workwear boots, and they were the first retailer to sell the boots as fashion items.

Scarlet shoes

The Docs were the couple's first attempt at design, and, buoyed by their success, they began to broaden their range into ripped T-shirts and punky frocks. Though neither had any fashion training, by 1984 the Hemingways were creating shoes in their own style – sandals, pumps, loafers and an array of boots; footwear had become a major force for them. They were using old stock of 1950s and 1960s canvas, as well as materials sourced from the Far East. Now all they needed was a name. They settled on Red or Dead, which refers to Wayne's Red Indian origins, as well as Gerardine's fascination with Russia. In 1985 the first

GARBO CHIC
Inspired by practical 1940s footwear and featuring a new signature print for Red or Dead, these shoes are named after screen-icon Greta, although whether she would have worn them is anyone's guess.

Red or Dead stores opened in Camden and Manchester, and in 1986 several more appeared in London's Soho, selling the first Red or Dead footwear range. The company excelled, going on to win the British Fashion Council's coveted 'Street Style Designer of the Year' award three years in a row.

UNION JACK
In celebration of the British summer, you'd have to check the forecast before chancing out in these plastic mules.

SHINING LIGHT
Ex-Red or Dead shoe design director Victoria Pratt sold these roller sole hologram sandals to ravers and kids across the globe.

"If you have ideas you can use them on anything from trainers to houses."

WAYNE HEMINGWAY, RED OR DEAD

OUTER SPACE
This cute 'Space baby' print appeared on a range of items including shoes, bags and even a wedding dress.

SPACE BABY
DON'T WORRY ABOUT THE FUTURE
YOU ARE IN SAFE HANDS

RED OR DEAD
SPRING SUMMER COLLECTION 1996

Upwardly mobile

1986

After the Marcos regime is overthrown, 1,200 pairs of designer shoes are found in Imelda's closets. The shoes become a symbol of her life of luxury amid the poverty of most Filipinos.

Former beauty queen Imelda and her husband, President Ferdinand Marcos, were forced to flee to Hawaii after $680 million was found missing from the Filipino treasury.

Shoe scandal of the century

Up until this enforced exile, Imelda Marcos was famed for travelling the world to buy new shoes at a time when millions of Filipinos were living in extreme poverty. But after 20 years in power, their corruption and fraud was discovered, and in their haste to vacate the country, the Marcos's left behind a presidential palace full of personal possessions, and the shoes were found. To rub salt into the wounds of the Filipinos, these weren't the handmade slip-ons worn by Marcos's cash-poor countrymen, but the designer names of Ferragamo, Givenchy, Chanel and Dior. Ferdinand Marcos died in 1989, while his widow was found guilty on corruption charges in the 1990s and sentenced to a

THE GAUDIER THE BETTER!
This multi-coloured pump from zany designer Thea Cadabra could only be 1980s!

minimum of 12 years in prison, but the conviction was overturned on appeal. She later reintegrated herself into Philippine life, and actually ran for president on several occasions!

Dressed for success

The 1980s were the 'me' decade, the era when image was everything. Power dressing was the pre-occupation of every aspiring yuppie; we're talking the glamorous, feminine variety here, with big hair, tailored suits complete with massive shoulder pads, crisp white blouses, sturdy handbags, bold jewellery, and bright, trowelled-on make-up. And on Madame's feet? Popular were shoes with a two-inch (or taller) skinny heel, accommodating various design treatments, including mixed skins, cutouts, several colours, and even short, silver chains.

Equally monied, but with no need to actually work for a living (in fashion terms at least), London's Sloanes stood for everything the yuppie detested: high-necked, frilly, ruffled blouses, pearls, floral skirts, loose short-sleeved shirt blouses, simple dresses, country tweed suits and low pump

SLOANE RANGER
These court shoes use the bold patterns of the 1980s but their textile uppers and unusually shaped heels make them timeless.

> " *They went into my closets looking for skeletons, but thank God, all they found were shoes, beautiful shoes.* "

IMELDA MARCOS, SHORTLY AFTER LEAVING THE PHILIPPINES

shoes. These 'sensible shoes' were advocated by the likes of Lady Diana Spencer and Margaret Thatcher. This low-maintenance style was sacrilege to fans of fancy footwear and heavenly heels. And worse was to come – the trainer…

IMELDA'S GIFT TO THE PHILIPPINES
The custom or endorsement of the world's best-known shoe collector must have been sought by every shoe shop and market stall in the Philippines, such was Imelda's fame when it came to shoes.

Homage to Imelda's shoes

After escaping the arm of the law, former First Lady Imelda Marcos used all the shoes she had bought over the years to open the Marikina City Footwear Museum in Manila in 2001. 'This museum is making a subject of notoriety into an object of beauty,' Imelda told reporters.

Personal trainers

1989

The Step Reebok shoe is launched after research shows that step aerobics is a highly effective form of cardiovascular exercise. Step classes breathe new life into gyms worldwide.

The birth of the trainer as a fashion item is often wrongly attributed to the New York Bronx of the 1980s. It was actually in the 1970s, on the football terraces and council estates of the UK's major cities, that the humble trainer took its first tentative steps. By the time of the post-punk revolution at the end of the decade, trainers such as adidas Samba and Puma Menotti had kicked fading Doc Martens into touch.

𝒯rainers as status symbols

Wearing the right make and style of shoes was an important way to gain status, fit in and earn respect on the street, at school and among your peers. As trainer designs grew ever more appealing, prices for them rocketed. It wasn't unheard

From plimsolls to Reeboks

The trainer's predecessor was the plimsoll. Consisting of a canvas upper and rubber sole, the plimsoll was designed as beachwear in the 1830s, and was affordable and popular. Shoes started to evolve for specific sports in the early 20th century (see 1920s bowling shoe below). Fast-forward to the 1980s, and advancements in footwear design combined with a need to look cool see plimsolls replaced by the latest cutting-edge models from Reebok, Nike and adidas, which consumers are prepared to pay a lot more for than the humble plimsoll!

TRAINER TRENDS

STREET CRED
Mid- and hi-top trainers such as the Fila BB84 were originally designed to prevent ankle injury, but as 'the street' was all about image, the style soon became more about fashion than function.

MY ADIDAS
With the track My adidas in 1986, Run-DMC were the first hip-hop stars associated with adidas. These days, however, hip-hop diva Missy Elliott even designs her own clothing range for the brand.

of for people to be mugged (or even killed) for their trainers.

Some bright spark figured that celebrity endorsement might push sales even higher. And they were right. Nike welcomed basketball legend Michael 'Air' Jordan aboard (paying him $1.5 million in 1989 alone), while adidas recruited hip-hop artists Run-DMC (who wore shell-toed adidas Superstars – without laces) to sing its praises. Between 1985 and 1989, sales of trainers in the US increased by about 23 per cent per year.

The hot shoe shuffle

Trainers were by no means restricted to certain groups. In 1982 Reebok introduced the first athletic shoe especially for women. Called the Freestyle, it soon became the darling of aerobics aficionados everywhere.

CELEBRITY POWER
The most famous face of adidas, David Beckham adds extra glamour and sex appeal to the already massive brand.

FREESTYLING
Inspired by new fitness trends, Eighties women were getting physical, prompting Reebok to design some new, flashy trainers to go with all that lycra.

Getting technical

Trainer designs changed quickly, with each new shoe flying off the shelves. Fierce competition forced the big boys to roll out the big guns. Reebok promoted its Pump, with the signature basketball pump on the tongue and an air valve release in the heel. Nike introduced Air Max 1, the first trainer to have revolutionary air cushioning. And adidas presented its Torsion system, designed to give extra support.

TROOP 'ICE LAMB'
Carrying on the trend for celebrity endorsement, 1980s brand Troop was promoted by rapper LL Cool J.

NIKE AIR JORDAN V
First introduced in 1985, the Nike Air Jordan series is a tribute to the legendary US basketball player Michael Jordan.

Smells like teen spirit

1991

The Seattle-based band Nirvana releases *Nevermind*, giving grunge music an international audience. The clothes follow the music, making grunge the big fashion trend of the early 1990s.

Grunge was about the music, the lyrics, the clothes and typical rock 'n' roll antics. It was best to look like yourself onstage and off, which in the cool, damp northwest of the US, where grunge originated, meant long hair and layers of inexpensive, often thrift-shop, clothing (these were struggling musicians, after all!): concert T-shirts, flannel shirts, hooded sweatshirts, bandanas or ski caps and jeans. The shoes? Weatherproof, utilitarian, non-flashy Dr. Martens or inexpensive Converse Chuck Taylors.

The grunge shoe movement

Fashionistas got their manicured hands on the movement, and soon mid-market shoe companies such as Sketchers and Candies, as well as the upmarket John Fluevog and designer Marc Jacobs, were making 'grunge shoes': big, clunky, heavy-soled Oxfords and so-called 'shit-kicker' boots that had the sturdy look of Dr. Martens with the casual attitude of Chuck Taylors. Further, Dr. Marten upped its own offerings, and soon the buckled Mary Jane Doc was the popular choice for female concert-goers, while chunky, military-style combat boots also had their 15 minutes of grungy fame.

Grunge and heroin chic

Grunge was also mentioned in the same breath as a style called heroin chic. It referred to the purported drug of choice by grunge musicians. The 'I don't care' wardrobe, near-emaciated body, dark eyes and unkempt hair were said to be typical of long-time heroin users. In truth, the two fashion 'movements' were often the exact same thing, although fashion stylists would smudge models' eyes with black, coax out a black bra strap from under a tank top, dress the models' feet in some

THE STAR OF THE SHOW
Grunge-style footwear was almost unisex and both boys and girls donned pairs of worn-down Converse Chuck Taylors, which symbolized the 'I don't care' attitude of the day.

kind of designer chunky shoes, and call the look heroin chic! With their skin-and-bone frames, lank hair and gaunt faces, the waif models personified the grunge and heroin chic fashion movements of this time.

Would there have been waifs without grunge? Maybe not. After all, it was no coincidence the two came onto the fashion scene at the same time. It's not that the jeans, concert T-shirts and shit-kicker boots of grunge needed a waif's slight frame; what was needed was a less 'out there' model than those of the 1980s. The waifs were perfect. So perfect, that when someone says heroin chic, it often isn't a grunge band such as Nirvana that comes to mind, it's a twig of a model dressed in ripped flannel and a chunky pair of shoes.

The perils of pedestals

1993

As the 1990s see a revival of the huge Seventies-style platforms, supermodel Naomi Campbell falls off her 10-inch cobalt Vivienne Westwood mock-crocs while on the catwalk in Paris.

Another famous platform-fall victim was Baby Spice Emma Bunton, who sprained her ankle when she fell off a pair of the platform trainers she and her Spice-mates were wearing.

Platforms are bad for your health

According to US statistics, nearly 43 million Americans seek help for foot problems each year, and British figures show that some 200,000 people in the UK are treated for footwear-related injuries; 10,000 of these are immediately taken to A&E. No word on exactly how many were wearing platforms, but health officials believe platforms – and their cousins, stilettos – cause the lion's share of these accidents. Many of the platform-clad injured are doing something as simple as turning around, stepping off a curb, or even walking straight ahead. Typical injuries include sprained and broken ankles, sprained knees, broken toes and even broken legs, arms, teeth and skulls!

CROCODILE SHOCK
Almost identical to Naomi's infamous mock-croc pair, these Westwood 'Super Elevated Ghillies' would cause more than just a red face if the wearer took a tumble...

Wannabes

The most popular shoes of 1993 were Patrick Cox's Wannabe loafers. Introduced a year earlier as a lower-priced line (or lower than Cox's primary line of footwear anyway!) of his-and-hers loafers, they were such a phenomenal success that they sold out as soon as they appeared. Shoppers took to bribing sales people at Cox's London shoe boutique, and essays about the shoe appeared in various newspapers and magazines. Cox has since sold over 400,000 pairs.

Available in flat and stack-heeled versions, the loafers were chunky without being ugly and oversize without sacrificing elegance. Their exaggerated silhouette looked edgy and urban, while giving the leg a flattering, long and slender appearance. And they were fun, constantly appearing in new colour/material combinations, including mock crocodile and python skin, and coloured suede. The line has since expanded to include pumps, boots and dress shoes, but the refined funkiness remains.

PATRICK COX
wannabe

PHOTOGRAPHED BY **DAVID LACHAPELLE**

" *The best compliment anyone could pay me is that they wore my shoes to death.* "

PATRICK COX

THE FERRAGAMO OF MTV
Created in 1992, Cox's Wannabe
loafers became famous for their
subversive-yet-classic designs.

NAKED AMBITION
With the Wannabes still going
strong after a decade – some with
higher heels – Cox's 2003 Wannabe
ads featured writer-actress-model
Sophie Dahl in various states of
undress. He didn't want her
wearing any clothes in case they
distracted people from the shoes!

GIRL POWER

The Spice Girls' debut single *Wannabe* reached number one in the UK in 1996, and their 'girl power' mantra – expressed through their songs, outspokenness and fashion sense – was warmly received by teenage girls.

Standing tall

Be yourself. That was the buzz-phrase of the 1990s when honesty and integrity were valued above all else. Stiletto Philosophy perfectly encapsulated this. It didn't mean you had to teeter round in six-inch spikes; instead it was about a state of mind, about deciding not to relinquish your femininity in order to succeed. Women wanted to be men's equals but didn't want to compromise on style, so Eighties power dressing – all mile-wide shoulder-pads and razor-sharp bobs – gave way to a more feminine look. Stiletto Philosophy was about being a sexy and powerful woman – proof that you no longer had to be one of the boys to get ahead. Hurrah!

Clearly superior

1996

Parisian shoe designer Christian Louboutin launches his famed transparent Lucite heels, in which flower petals or other objects are seen to be floating. They become hugely popular.

This was a year of femininity – in the classical sense. Clothes got sleeker, hair got longer, pedicures became an obsession among the fashion-conscious of urban centres such as New York, and everyone who was anyone was seen with a brightly coloured – or perhaps pastel – pashmina, and dress-up shoes crept into vogue after seasons of chunky footwear.

Clearly in fashion

One of the shoe fashion darlings of 1996 – at least among the fashion elite – was Parisian designer Christian Louboutin. When he attached transparent 'Lucite' heels to sandals, pumps and mules, his clientele loved them. Some heels were left clear, but most encased flower petals, gold leaf, faux jewels, travel souvenirs and other sparkly or amusing things.

Europe's beautiful people – Princess Caroline of Monaco, Catherine Deneuve – help make the shoe one of Louboutin's best-selling concepts and prompted him to include Lucite heels in each following year's line-up. Americans also loved the Lucite footwear; Elizabeth Taylor and Cher are fans, as is designer Diane Von Furstenberg

Fast-forward to the early 21st century, and Louboutin's 2005 collection boasts sandals, mules, slingbacks; flats, kitten heels and traditional high heels; all with the clear heels, but also with PVC straps, making it appear as if the foot is floating. Beads, satin bows and other decorations appear to be resting directly against the skin.

> " *My shoes are like faces. Some are beautiful from the front; others are more interesting in profile.* "
>
> *CHRISTIAN LOUBOUTIN*

THE SEE-THROUGH SHOE
Louboutin's transparent Lucite heel has become his signature. These sandals go a step further with clear PVC straps.

Shoes, sex and the city

1998

Four friends, lots of sex – and shoes. Dozens of pairs to go with the most fabulous outfits. Yes, it's *Sex and the City*, the series that made prolific shoe consumption a worthy pursuit!

Even before checking out what Carrie, Miranda, Samantha and Charlotte were wearing on the rest of their bodies, we ogled their footwear. The show's producers, realizing this, created special shoe-centric episodes, such as the episode 'A Woman's Right to Shoes'. Carrie attends her friend Kyra's party, at which guests have to remove their shoes. Upon leaving, Carrie discovers to her horror that her brand new Manolos have been stolen. Kyra offers to pay for the missing shoes, but balks when she discovers they cost $485. Carrie leaves the apartment empty-handed (or, rather, bare-footed), with a sense of shoe-induced shame.

Shoe issues

Remember 'Ring a Ding Ding', where Carrie finds herself in dire straits financially? On a shoe-shopping excursion with Miranda, Carrie realizes she's spent $40,000 on shoes! And then there was 'What Goes Around Comes Around', in which Carrie gets mugged. 'Please, sir,' she pleads, 'You can take my Fendi baguette, you can take my ring and my watch, but don't take my Manolo Blahniks.' Unfortunately for Carrie, the mugger did just that, and ran off with her favourite pair of strappy sandals. Fans all over the world mourned with their heroine.

How it all started

Before *Sex and the City* was an HBO series, it was a book, and before that, it was a column that appeared monthly in the *New York Observer*. The brainchild of writer Candace Bushnell, the column celebrated Bushnell's big city adventures – in and out of the bed. An attractive blonde in spike-heeled Manolos, Bushnell hung out with a gaggle of party-loving creative types and enjoyed a life of urban adventure, cocktails, flirtations, romance, and lots of shopping. Her writing proved so popular that the columns were collected into a

THE GIRLS
From left: Charlotte, the wealthy one; Carrie, the shoe-aholic; Samantha, who would try anything once; and Miranda, the preppy lawyer.

The cast of characters

Carrie: Sex columnist Carrie Bradshaw is the character modelled after *Sex and the City* creator, Candace Bushnell. Carrie is the show's fashion renegade, pairing Miu Miu, Dior and Blahnik in the same outfit, wearing a tutu with a T-shirt, a tiara with boots (high-heeled stilettos of course). Fashionistas regularly tuned in to see what Carrie was wearing, getting inspiration from her chameleon style.

Samantha: Her *Sex and the City*-style includes body-flattering suits in strong colours plus plenty of risqué lingerie, sexy shoes and figure-hugging dresses.

Charlotte: The Park Avenue ingénue who dresses the part. Think pastels and pearl earrings, neat hair and barely-there make-up, and shoes that are just noticeable enough.

Miranda: The lawyer dresses slightly preppy by day, with power-style suits that are smartly tailored. And also slightly preppy at night, but with slip dresses, cardigans, almost-sensible shoes and fun accessories.

SHOES, SHOES, SHOES
Carrie Bradshaw, the shoe-loving central character of *Sex and the City*, looks longingly at yet another potential member of her impressive shoe collection.

"I've spent $40,000 on shoes and I have no place to live? I will literally be the old woman who lived in her shoes!"

CARRIE BRADSHAW

book by the same name, from which the series was developed.

One of the premises of the first show was: can a woman have sex like a man? This created quite a bit of controversy because a lot of men said no, no, no. They didn't want women having uncommitted sex. Why not? Sensual equality can be a fabulous and very fun thing. But truth be told, sex wasn't the only reason we watched Carrie, Samantha, Miranda and Charlotte. We also tuned in to check out what they were wearing on their feet!

It's no secret that Carrie's favourite shoe designer was Manolo Blahnik. There was a time when the designer was barely known outside of the rarified fashion world of New York-London-Paris. Fortunately for shoe lovers in mid-sized cities and small towns all over, *Sex and the City* came along and introduced viewers everywhere to the high-heeled wonders of 'Manolos'. A bit more about the genius himself:

> *"Manolo Blahnik's shoes are as good as sex . . . and they last longer."*
>
> MADONNA

ECLECTIC STYLE
Fashionistas regularly watched 'Sex' to see what Carrie was wearing, getting inspiration from the character's chameleon style. Here she is strolling down Park Avenue in her Christian Louboutin stilettos.

Which one are you?

Carrie, Miranda, Samantha, Charlotte – curious to know which *Sex and the City* gal you most resemble? Go to www.yournewromance.com/cityquiz.html and find out.

Manolo Blahnik

Born in Santa Cruz de la Palma, Canary Islands, 1942, Blahnik was born to a Czech father and Spanish mother and raised with his sister on the family's banana plantation. From bananas to shoes? In 1965, Blahnik went to Paris to study art and stage design, working at a vintage clothing store to support himself. There he developed an appreciation of the fashionable clothes his mother had so loved. Relocating to London in the 1970s, he became an artist and fashion photographer. It was during a 1971 visit to New York that Blahnik met with *Vogue* USA editor Diana Vreeland. Though the meeting was to show Vreeland his portfolio of drawings and set designs, Freeland clearly preferred Blahnik's shoe sketches. So taken was she that she persuaded Blahnik to become a shoe designer. The rest, as they say, is history. However, his fame grew beyond fashion circles in the early 1990s when his name was mentioned several times on the hit British comedy *Absolutely Fabulous*.

A MAN OF MANY TALENTS
Manolo Blahnik was a talented artist before he became a shoe designer. This is one of his illustrations – quite exquisite!

But it was in the late 1990s, when Sarah Jessica Parker's character in *Sex and the City* proclaimed her obsession for Manolos, that Blahnik's name reached household status. Best known for his hard-to-find, gorgeous (if somewhat impractical) shoes favoured by the world's beautiful people, Blahnik designs the shoes himself, using no assistants or apprentices. The man's a legend.

PERFECTION ON FEET
Another favourite of Carrie's, Jimmy Choo is known for gorgeous, handcrafted women's shoes that always look appropriate, in a sexy, young, fashionista kind of way.

> *" The secret of toe cleavage is a very important part of the sexuality of the shoe; you must only show the first two cracks."*

MANOLO BLAHNIK

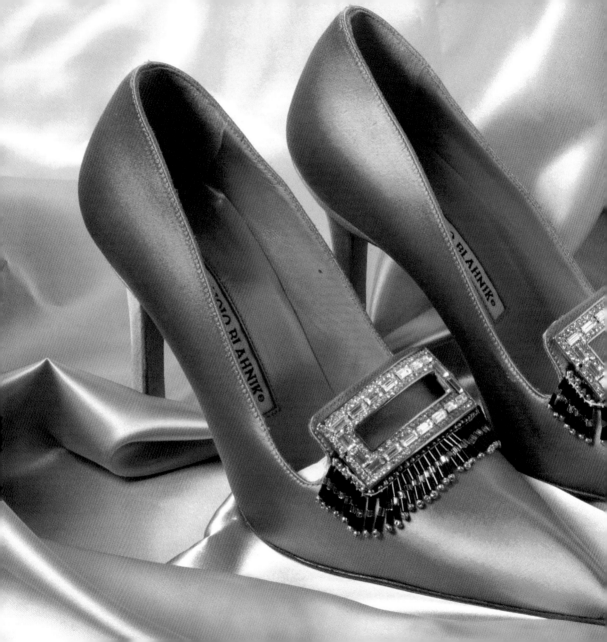

The Shape of Things to Come

As we entered the new millennium, women defined themselves by the shoes they wore: label-mania for design-house fanatics; vintage for authenicates; Uggs for city gals who wanted winter comfort mixed with the cachet of a waiting list; limited-edition Birkenstocks for those who wanted the same in summer. Meanwhile, democracy ruled as designers started creating budget lines for the high street, and eBay meant Choos and Manolos for all (or a decent second-hand pair at least!) Ah, what a fabulous time to be a shoe lover!

7 *2000+*

Making a point

2001

Pointy-toed stilettos are no longer the preserve of the chauffeured Ladies Who Lunch set. Thanks to affordable high street copies, everyone is now able to own a pair of vertiginous heels.

From the high street to high-end boutiques, pointed shoes in exotic colours were everywhere and – boom! – a new urban uniform was born: pointy-toed stilettos, figure-hugging bootcut jeans (preferably by Miss Sixty, Earl Jeans, Seven or Juicy Couture) and a sexy top.

Stiletto peril

The problem of navigating public transport in four-inch spindly stilettos meant carrying a pair of trainers in your handbag and slipping them on (or off) at the right moment. 'Women who wear stilettos will slip on a pair of trainers to be more comfortable, but they really don't want to be seen in flatties,' explained handbag designer and stiletto devotee Lulu Guinness

DRESSING DOWN
Best known for his simple, elegant sandals, Joseph Azagury indulged in some pointy evening shoes – to be worn with jeans, of course.

(who, incidentally, managed to walk the Great Wall of China in heels on her honeymoon in 1986). Heels had to be high – and they had to have a twist, be it conical, wedge, anything so long as it was theatrical (the kaleidoscopic *Moulin Rouge* was the year's hottest film, after all).

The Pointer Sisters

The look was adopted by everyone from party girls and media madams to off-duty celebs. Gwyneth Paltrow, Cameron Diaz and Kirsten Dunst all personified the oh-so-casual look at many a low-key premiere. In fact, Gwyneth rocked the jeans-and-heels look so well that US denim label Blue Cult named a style of jeans after her.

Suffer for your shoes

Squeezing your feet into a shape that was so unnatural and frequently ill-fitting had its consequences, of course: corns, bunions and post-party calf ache all became common complaints. Manufacturers rushed to the rescue with gel-filled pads to ease the pain of the pointiest shoes, and surgeons offered collagen-padding injections.

Along with the trend for super-sized heels came a glut of warnings from healthcare professionals prompted, no doubt, by high-profile accidents such as actress Chloe Sevigny falling off her sky-high Balenciaga boots at a Manhattan fashion party – and losing her front teeth.

WHAT'S THE POINT?
After paying the earth for the latest designer points in the brightest colour available, it was then fashionable to hide your new pride-and-joys under a long pair of bootcut jeans.

To wear or not to wear?

The evidence was what every fan had secretly feared. All high heels are bad for the bones, we were told, since they gradually increase the inward-twisting pressure on the knee joint. According to one 2001 survey from the Society of Chiropodists and Podiatrists, women have four times as many foot problems as men! And in yet more shoe-related research, nearly 60 per cent of women respondents said they were wearing uncomfortable shoes for at least an hour a day. Foot spas had suddenly never looked so appealing...

But there was finally enough good news for stiletto fans to stop worrying when researchers at Harvard Medical School discovered that stilettos do less damage to a woman's knees than shoes with thicker high heels. (Wide-based high heels were found to increase pressure by 26 per cent; stilettos by only 22 per cent!) Which didn't necessarily mean that stilettos were good for your health, but it was enough of a green light for any woman who'd actually been aware of the research to carry on wearing her stilettos anyway!

SUITED AND BOOTED
Never straying far from their trademark elegance, design partnership Elizabeth Rickard and Binith Shah show how to bring a touch of glamour to even the simplest of pointed day boots.

The highs and lows

2003

Prestigious shoe designer Jimmy Choo is recognized by the British establishment for his services to fashion, but the masses opt for low-level comfort instead.

This was the year a cobbler received an official honour, when Jimmy Choo, beloved designer of wealthy fashionistas, received an OBE for services to the fashion industry. Born in Malaysia in 1961 into a family of shoemakers, Choo created his first pair of heels at the age of 11. After studying at London's Cordwainers College alongside such luminaries as Patrick Cox and Emma Hope, he opened a small boutique in Mayfair. The rest, as they say...

All of Choo's shoes are handmade – he makes just two pairs a day – and bespoke, with women coming into his shop

RED CARPET CHIC
Jimmy Choos stole the show at the 2003 Oscars.

SINGING THE CHOOS
Elegant and stylish, Jimmy Choos have been hailed as the height of feminine fashion.

Designer 'solemates'

Canny designers have now created an expensive shoe to suit every age, mood and personality. Think you're va-va-voom? Then it's Jimmy Choo or nothing. More avant-garde? Try Rickard Shah (left) or Dries Van Noten. See yourself as chic? Stick with Yves Saint Laurent. Perhaps you're a creative original? Try eccentric Canadian John Fluevog. Or maybe you're just an old-fashioned romantic, in which case Claudia Ciuti is for you. Then again, we have a different persona for every occasion, so if in doubt why not buy a pair to suit your every whim?

" *For a woman, the right shoe can make everything different. It can make you walk better, feel better.* "

JIMMY CHOO

for made-to-measure fittings or faxing detailed photocopies of their feet. Devotees rave about his feminine designs – always elegant, never too slavish to the whims of fashion – and their comfortable fit. Princess Diana was perhaps his most famous client, with Jimmy becoming a regular visitor to Kensington Palace. Indeed, he had just finished making her a pair of gold slingbacks (she disliked a shoe with an ankle strap) when she died. But the extent of his celebrity following was demonstrated at the 2003 Oscars, when 45 pairs of Jimmy Choos were spotted on the red carpet!

A podiatrist's perfect shoe

In an oh-so-ironic turn of events, while the kings of the killer heel were being lauded, the public rediscovered the joys of flat-shoed comfort, and summer 2003 saw record-breaking queues outside Birkenstock's flagship Covent Garden store – there were even rumours of a one-pair-per-customer rule.

It's not often that a podiatrist's idea of the perfect shoe becomes a favourite with fashionistas. Family-run from the

BIRKENSTOCK BLISS
For the ultimate in comfort and chic, new Birkenstock sandals should be professionally fitted.

tiny German town of Bad Honnef since 1774, Birkenstock produces sandals renowned for their comfort, with adjustable straps and moulded ergonomic curves.

For years, Birkenstock was a laughing stock, a sandal for 1960s' hippy throwbacks and vegans. However, it slowly crept its way back on to the feet of hip urbanites, helped largely by the birth of 50 or so new styles in a wide range of appealing colours. The must-have style of the summer was the single-strap Madrid in white or silver, while a limited-edition range by German supermodel Heidi Klum (who is said to have used her garlic press to customize the shoes with beads and studs) only added to the sandal's new-found cachet.

THE 'UGLY' BOOT
Created 40 years ago by Aussie surfers wanting to warm their post-surf feet, the sheepskin-lined Ugg (short for ugly) boot became the 'must-have' boot when celebrities such as Kate Moss were seen sporting them. A great way to keep the toes toasty without sacrificing winter wardrobe style!

Anything goes

2004

The trend for online shopping has a huge impact on wardrobes worldwide. But while Gucci Girls romp through eBay, the high street is awash with a range of different styles.

Thanks to the popularity of vintage, 2004 was all about the individual and an anything-goes attitude, so long as it was suitably breezy and bohemian. Sienna Miller was the girl of the moment and her 'boho' style – kaftan tops, chunky belts and bashed-up boots dominated street fashion and catwalks alike. And authenticity was key. Your cowboys boots had to be from the 1970s, preferably the product of a genuine Texan cobbler, your disco heels from Charles Jourdan. As vintage moved from specialist retailers to shops on the high street, women started paying a premium for second-hand, sometimes hygienically challenged shoes!

Cyber shoes

Consumers had more choice than ever before. Apart from the increased availability of second-hand vintage shoes, in 2004 it seemed that there was nothing you could not buy or sell on eBay, and buying and selling unwanted designer clothes on the net became a bone fide means of either making a bit of extra cash or buying those designer labels you had never been able to afford before. Designer shoes in particular were doing a roaring trade. Most-watched are the big-name designers – Blahnik, Choo, Louboutin – fake as well as real (authenticity has no place in cyber space). Few women can resist the charm of Manolo Blahnik's shoes. Knock-off Manolo Mary Janes, star of a seminal episode of *Sex and the City,* in which they were described in almost mythical proportions, became

BRILLIANT BURBERRY
No longer just the choice of yuppies and your granny, Burberry turned its fortunes around and is now a mass-market name.

TOP OF THE SHOPS
Olivia Morris was among the designers who created shoes for high street stores, such as this golden wedge made for Top Shop.

WELLY NICE!
Not normally the height of fashion, 2004 saw welly boots hit the high street in a combination of cool patterns and bright colours.

BLING BLING
Originally designed on canvas in 1896, Louis Vuitton's eyecatching mini flowers monogram never leaves any doubt about which label you're wearing.

You and your shoes

Shoes talk, whether or not we like what they have to say, so before you draw conclusions based on someone else's footwear, consider first what the delights on your feet say about you.

Mules as daywear: you're an old-fashioned, diva-style seductress who lives for male attention. Do your hairslides have feathers? You may be the reincarnation of Zsa Zsa Gabor.

Dr. Martens (if you're over 30): you work in a record or video shop. Or maybe you date a guy in a Cure cover band – or are in one yourself.

Brown Oxfords: a librarian, a literature student or an assistant in a 'lifestyle' shop? No? Well, you do realize that's how you come across?

Walking shoes, worn all day, every day: you may be just be prone to foot pain but your safe, comfy fashion-sense makes you seem the sympathetic type and you are forever brewing coffee and listening to other people's problems.

Slip-on leather loafers: there's a good chance you're an 'everywoman' – with a husband and at least one child at home and on the career track in a serious field. Your hair and make-up are sensible and your briefcase matches your shoes.

Extreme heels: are you a stripper? Or an escort? Or perhaps you're just a vixen who likes to walk on the wild side.

Jimmy Choos, Manolo Blahniks et al: you're either a fashion follower with money, a fashion follower with a wealthy lover, or a fashion follower who scours eBay for good deals on your favourite high-end footwear.

the fake of choice, selling for around £60 (about $US110), less than a tenth of the retail price for a genuine pair.

Anything goes

Only four years previously, labels had been for showing off. This flashy 'bling bling' attitude could be applied to the simplest of shoes. Status symbol footwear included stilettos covered in the famous Gucci 'Gs', and Christian Dior's trainers still sport heel-to-toe 'Dior' in pink or blue, just in case anyone had any doubt where they were from and, of course, how much you'd spent. And why stop there? A matching 'Dior Charms' bag with a giant 'D' clasp perfectly finished off the flashy look.

The high street gets poshed up

Just as eBay was now allowing access to all these designer labels, high street retailers started turning to the big name designers

The shoe people

You know you're a shoe person when:
• You watch *Sex in the City* for the shoes, not the characters.
• Your new fuchsia, snakeskin go-go boots don't match anything in your wardrobe, but you just had to have them!
• You've spent an entire paycheck on one pair of sandals (but hey, they had rhinestones and such a nice heel…).
• You wear stilettos to walk the dog.
• You often come across shoes in your closet that you forgot you had and have no idea where or when you bought them.
• You have several pairs of ill-fitting shoes in your collection that you wear regularly because they look so good.
• You go on a week's holiday and take seven pairs of shoes (not counting your flip-flops or the ones you wore on the plane).

(Karl Lagerfeld, Luella Bartley, Tracy Boyd) too, for a boost in cachet as well as an injection of fresh ideas – Olivia Morris's range for the UK's Top Shop used quirky, brightly coloured styles with floral embroidery. Cheap chic became as cool as full-price designer goods, and boasting about how little

COOL COMFORT
If flashy wasn't your style, it was just as cool to be seen in sleekly designed comfortable trainers.

CUSTOMIZED COUTURE
To counteract the commercial bling, many fashionistas turned to customized bespoke, to boutiques such as Rickard Shah, in an attempt to stamp some individuality on their footwear.

your outfit cost (proof that you were smart and creative enough not to need top-to-tail designerwear) suddenly became the ultimate in sartorial one-upmanship.

Bespoke bites back

Bespoke shoes were also making a quiet comeback. Logos had been all about fitting in, keeping up with the Joneses; bespoke, on the other hand, was about asserting your individuality – provided you had the money, of course. At Rickard Shah, a couturier in the heart of Belgravia, London, customers willing to part with several hundred pounds could choose everything from the shoe's colour, fabric details and heel height to the personalized message stamped on the sole: 'Flashiness is next to godliness,' perhaps?

Ssssssssh!

And there was more than one way to wear designer. Wanting to stay a step ahead of the masses, wealthy designer junkies turned to stealth labels and hard-to-find lines. A pair of limited-edition Marc Jacob sequined pumps, signed by the designer himself, from Colette, a so-hip-it-hurts boutique in Paris, perfectly summed up this new attitude. Why? Because only the truly elite, those really in the know, would recognize the relevance of your footwear.

ALL THINGS BRIGHT AND BEAUTIFUL
No matter what your choice of footwear, asserting your individuality was a key trend in 2004, and the bigger and brighter the statement the better.

If the shoe fits

An empty wallet may not be the only price you pay for the latest style in footwear. Podiatrists estimate that up to 85 per cent of the female population wear ill-fitting shoes, causing a whole host of conditions including bunions, corns and calluses, as well as lower back pain, fatigue and even accidents. (A poorly fitting shoe also wears out faster than a well-fitting one, putting even more strain on those purse strings.) But don't swap your favourite Patrick Cox's for a pair of boring brogues just yet; here's some help in ensuring your feet are both stylish and comfortable.

Shop till you drop

- Shop for shoes in the afternoon. Your feet swell as the day wears on, meaning late-day feet can be half a size larger than they were first thing.
- Select a shoe that is close to the shape of your foot. If you have lots of width in your toe area, a pointy-toed shoe is going to hurt, no matter what its size.

- Have your feet professionally measured. Weight gain, age, gravity and pregnancy can all cause feet to enlarge. Furthermore, not all manufacturers size their shoes the same, so just because your Manolos are a six, it doesn't mean your Birkenstocks will be.
- Leave at least a centimetre between your toes and the end of the shoe, and enough space for them to lie flat. Squashing the toes can cause unsightly corns and lead to toe deformities.
- Your heel should fit comfortably in the shoe with minimum slippage. Make sure there is some slippage, however, or you'll end up with big-time blisters!
- When trying on shoes, walk through the shop, stand on your toes, rock onto your heels, do a few turns. Make sure the shoes are a perfect fit, even if you look like a fool!

MADE TO LAST
Shoemakers design shoes around wooden, foot-shaped blocks called lasts. Different lasts exist for different sizes and styles, although whether a Thea Cadabra or an Oxford brogue, the parts of a shoe are unmistakable.

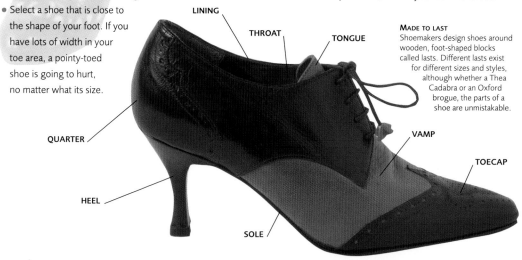

LINING

THROAT

TONGUE

QUARTER

VAMP

TOECAP

HEEL

SOLE

Shoes inside and out

For those of you who don't spend much time around cobblers (a majority perhaps), here's a breakdown of your best Jimmy Choos:

- Vamp: this is the front part of shoe upper, attached to the sole. It is often composed of more than one piece, creating a decorative pattern.
- Quarter: basically the back of the shoe – sometimes also creeping around towards the sides.
- Throat: the area where your foot enters the shoe. A shoe's throat dictates how wide a shoe can be.
- Toecap: the decorative or reinforced area above the toes, although cheaper shoes usually leave it out and certain styles of footwear just don't need one.
- Lining: not all shoes have linings, though they are common in high-quality footwear. A shoe's lining may be made of leather, fabric or a synthetic material.
- Sole: the term derives from 'solea', the Latin word for ground, and refers to the bottom of the shoe where it touches the, er, ground.
- Tongue: padding fitted behind the vamp to prevent irritation from the shoe fastenings.

Can a poor-fitting shoe be fixed?

In a word, no. Or at least, not much. But there are things you can do to make ill-fitting footwear more comfortable:

- Shoe too large? Wear a thicker sock. Or two pairs of stockings. Maybe three. If that doesn't work, try an insert, such as the ones made by Dr. Scholl.
- Heel-lift in a new pair of boots? Don't worry if your heel shimmies up and down, leather boots often contour to your feet as the boot ages. Failing that, try an insert called a heel shim, which prevents those embarrassing wobbles.

Shoe care made easy

- Don't create a shoe pile at the back of your wardrobe. The shoes will get squashed and you'll go mad trying to find your favourites – not good if you are about to go out for the evening. Instead keep them on a rack or in their original boxes.
- Buy a shoehorn and use it when shoes are difficult to put on. This will keep you from breaking down the backs (and those newly manicured nails!) as you struggle.
- Don't wear high heels if you plan to do a lot of walking – you'll damage the heels *and* end up covered in blisters! Not a good look when the sandals come out in summer.
- Clean your shoes after each wearing with the appropriate product for the material. Not only will you feel great putting on a pair of clean, shiny shoes but smart footwear creates a much better impression too.

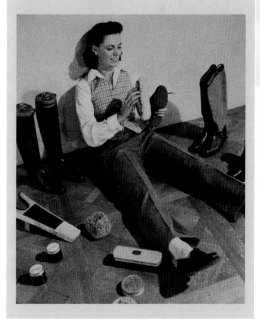

Index

Acknowledgments

Author's acknowledgment: I couldn't have finished 'The Shoe Book' without the support of the following people: my husband Richard Demler and our sons L.C. Pedersen and A.G. Pedersen; my sister Holly Lynne Pedersen, who is like an anchor; Nancy Bloom and Carla Hall for love and laughter; Damien Moore, Clare Wallis and the rest of the patient, talented team at Studio Cactus; and to you, dear reader, for your interest.

Studio Cactus would like to thank: The folk at Northampton Museums' shoe exhibition for their invaluable contribution to this project; in particular, Rebecca Shawcross and Sue Constable – what they don't know about shoes isn't worth knowing! A special thank you to Charlotte Williamson. Also to Sharon Cluett, Dawn Terrey and Laura Watson for design; Sharon Cluett again for her illustrations; Clare Wallis, Ame Verso, Aaron Brown and Lorna Hankin for their editing; Polly Boyd for proofreading; and Jackie Brind for indexing. Thanks also to Kerrie Fowler, Alison Lubbock and Alex Stevenson for research material. As always, many thanks to Madeleine and Jacky. And lastly, grateful thanks to adidas, Birkenstock, Christian Louboutin, Converse, Charles Jourdan, Dr. Marten, Ferragamo, Gaza Bowen, Jimmy Choo, Joseph Azagury; Louis Vuitton, Manolo Blahnik, Patrick Cox, Reebok, Rickard Shah, Red or Dead, Topshop, Underground, Ugg and Well Heeled for use of their fabulous pictures.

Picture credits

Courtesy of adidas: 52bl, 53t, 53bl, 53br, 103c; S.I.N/Alamy: 105r; akg-images: 33br, akg-images/Album/Paramount Pictures: 78l; Bridgeman Art Library: 18b, 19c; courtesy of Birkenstock: 119t; Capital Pictures: 110b; courtesy of CBS Paramount Int'l Television: 111r, 112l; courtesy of Charles Jourdan: 69bl; courtesy of Christian Louboutin: 56tr, 109kb, 109br, 123r; courtesy of Converse: 36cr, 36kb, 37tl, 37c, 96, 104bl; ©Bettmann/Corbis: 20bl, 40b, 44l, 60c, 61tr, 65bl, 66b, 71, 79t; ©Hulton-Deutsch Collection/Corbis: 38, 46c, 49c, 61l, 68, 72, 81t; ©Sandro Vannini/Corbis: 42b; Leonard de Silva/Corbis: 45; ©Underwood & Underwood: 64l; Maiman Rick: 64br; David Lees/Corbis: 67c; Mitchell Gerber/Corbis: 86cr; Sunset Boulevard/ Corbis Sygma: 90l; ©Romeo Ranoco/ Reuters/Corbis: 101r; courtesy of Dr. Martens: 88t, 88bl, 88br, 89r, 89bl, 89br; courtesy of Ferragamo: 47bl, 47bc, 47br, 48bl, 48bc, 48br, 67tr, 67cr, 67br; courtesy of Gaza Bowen: 93b; Ranald Mackechnie/Getty Images: 6; Getty Images: 54; Keystone/Getty Images: 69tr; Richard Bradbury/Getty Images: 84; Ryan MacVay: 89l; Digital Vision/Getty Images: 91b; courtesy of Jimmy Choo: 113r, 118bl, 188c; courtesy of Joseph Azagury: 116c; courtesy of Louis Vuitton: 121bl; courtesy of Manolo Blahnik: 113kb, 113C; Mary Evans Picture Library: 18c, 32c, 47; Ministère de la culture: 87cl; courtesy of Northampton Shoe Museum: 14, 23bl; PA/Empics: 108; courtesy of Patrick Cox: 107l; Photos.com: 10l, 10kb, 12l, 33kb, 48c, 55tr, 70kb, 74kb, 82l, 86kb, 98kb, 100kb. 102kb, 103kb, 105l, 123kb; PhotoDisc: 104kb; courtesy of Reebok: 103cr; Rex Features: 85c; courtesy of Rickard Shah: 117br, 122bl, 127; courtesy of Red or Dead: 98b, 99tl, 99c, 99br, 99kb; courtesy of Topshop: 121tl; courtesy of Underground: 75l, 75br, 122cr; V&A Images/Victoria and Albert Museum: 21c; courtesy of Ugg: 119b; courtesy of Well Heeled: 116l, 116tr. Jacket: Jim Naughton/Getty Images; courtesy of Rickard Shah; courtesy of Jimmy Choo. All other images ©Studio Cactus

Also in this series...

Lacy, padded, push-up, strapless, halter, balconette, minimizer, maximizer – the bra in all its glorious forms is celebrated in this sassy book for fashionable girls everywhere.

Bra: A Thousand Years of Style, Support and Seduction
ISBN 0 7153-2067-X

"As this lively book points out, the bra has had more of an impact on shaping – quite literally – generations of women than any other garment...It's all brought back to life by archive photographs and facts guaranteed to make you see your bra in a whole new light."

Mail on Sunday